THE ART OF DRA...

POSES

FOR BEGINNERS

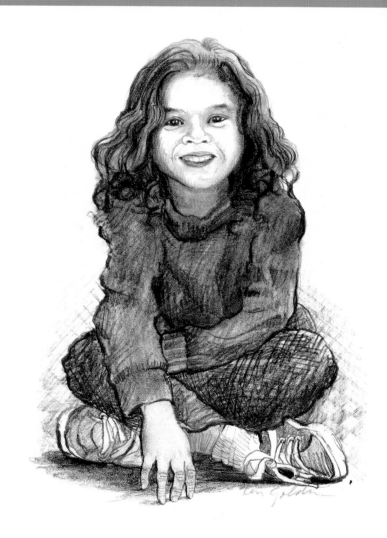

Ken Goldman & Stephanie Goldman

Walter Foster

Inspiring | Educating | Creating | Entertaining

Brimming with creative inspiration, how-to projects, and useful information to enrich your everyday life, quarto.com is a favorite destination for those pursuing their interests and passions.

First published in 2022 by Walter Foster Publishing, an imprint of The Quarto Group. 100 Cummings Center, Suite 265D, Beverly, MA 01915, USA.
T (978) 282-9590 F (978) 283-2742 www.quarto.com • www.walterfoster.com

Walter Foster Publishing titles are also available at discount for retail, wholesale, promotional, and bulk purchase. For details, contact the Special Sales Manager by email at specialsales@quarto.com or by mail at The Quarto Group, Attn: Special Sales Manager, 100 Cummings Center, Suite 265D, Beverly, MA 01915, USA.

ISBN: 978-1-60058-945-4

Digital edition published in 2022
eISBN: 978-1-60058-944-7

Proofreading by Grace Wynter, Tessera Editorial

Printed in China
10 9 8 7 6 5 4 3 2 1

THE ART OF **DRAWING** POSES
FOR BEGINNERS

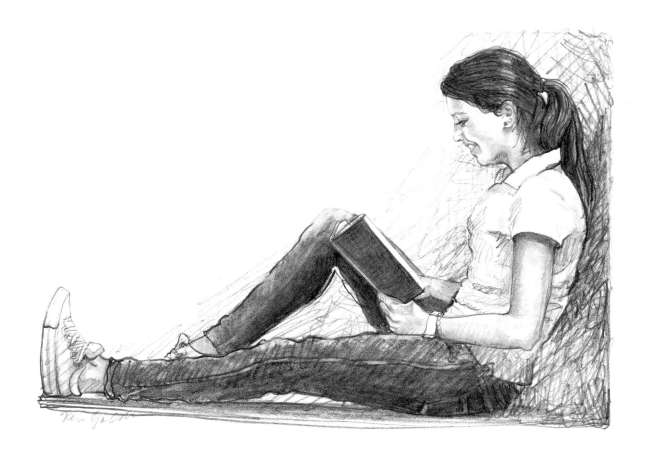

CONTENTS

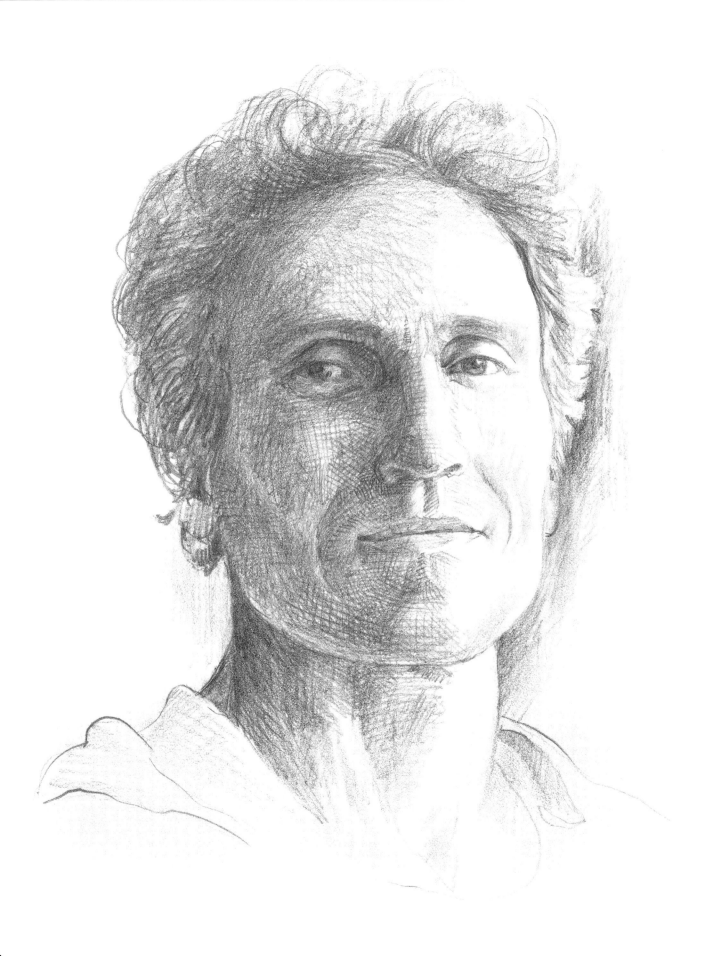

INTRODUCTION

Perhaps there is no other subject in art that is more intimate or rewarding than figure drawing. From the earliest cave paintings to stunning artwork by Michelangelo, the human fascination with capturing our likeness in two-dimensional form spans thousands of years. Today, it remains one of the most popular subjects in art education.

The Art of Drawing Poses for Beginners offers everything you need to begin or further your journey in drawing people. Featuring artwork and instruction from renowned artists Ken and Stephanie Goldman, this book provides a strong foundation for figure drawing by first discussing anatomy and human proportions in great detail. Tips, exercises, and example drawings are then offered, covering topics such as suggesting movement, rendering age, conveying emotion, and creating engaging compositions. Featuring references showcasing a wide variety of poses—from traditional stances to figures in action and children at play—you can develop your skills for hours upon hours with no need for a model. Practice is the key to success, and with *The Art of Drawing Poses for Beginners*, you'll have more than enough material to master the art of drawing people.

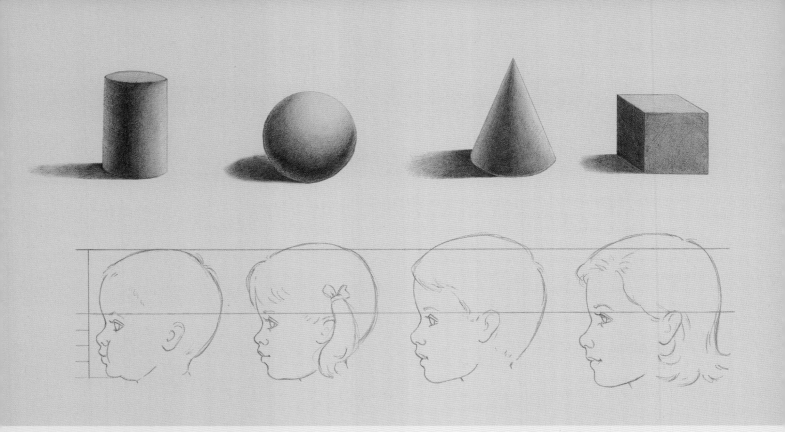

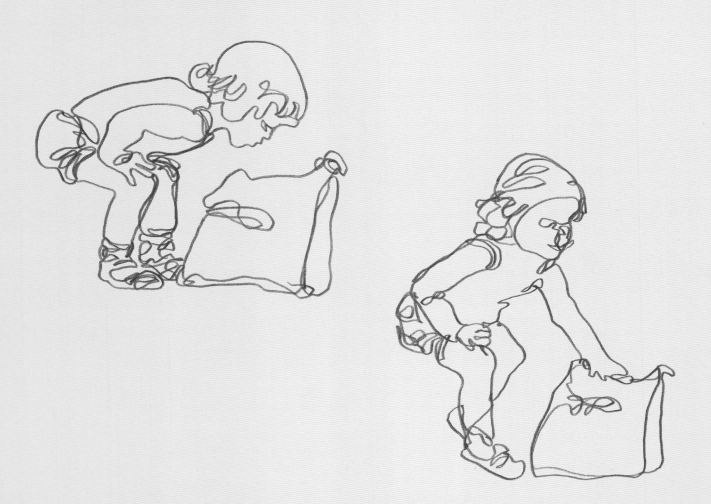

Chapter 1

GETTING STARTED

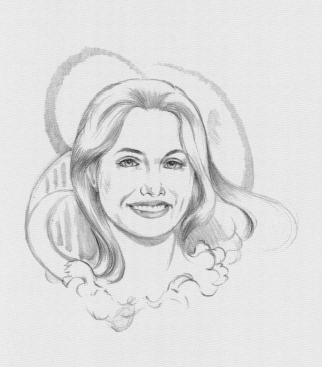

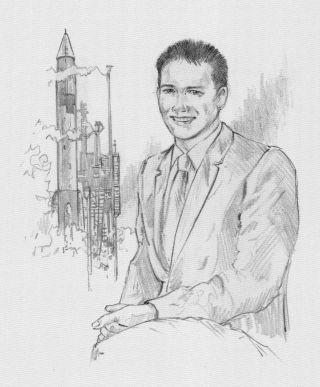

TOOLS & MATERIALS

For graphite drawing, you do not need a lot of materials to get started. Collect a few pencils of different hardnesses, different kinds of paper, and begin drawing! Over time you will learn what tools and materials work best for what you are trying to achieve.

Drawing Paper Drawing paper is available in a range of surface textures (called "tooth"), including smooth grain (plate finish and hot pressed), medium grain (cold pressed), and rough to very rough. Cold-pressed paper is the most versatile and is great for a variety of drawing techniques. For finished works of art, using single sheets of drawing paper is best.

Sketch Pads Sketch pads come in many shapes and sizes. Although most are not designed for finished artwork, they are useful for working out your ideas.

Erasers There are several types of art erasers. Plastic erasers are useful for removing hard pencil marks and large areas. Kneaded erasers (a must) can be molded into different shapes and used to dab at an area, gently lifting tone from the paper.

Tortillons These paper "stumps" can be used to blend and soften small areas when your finger or a cloth is too large. You also can use the sides to blend large areas quickly. Once the tortillons become dirty, simply rub them on a cloth, and they're ready to go again.

DRAWING IMPLEMENTS

Drawing pencils, the most common drawing tool and the focus of this book, contain a graphite center. They are categorized by hardness, or grade, from very soft (9B) to very hard (9H). A good starter set includes a 6B, 4B, 2B, HB, B, 2H, 4H, and 6H. The chart below shows a variety of drawing tools and the kinds of strokes you can achieve with each one.

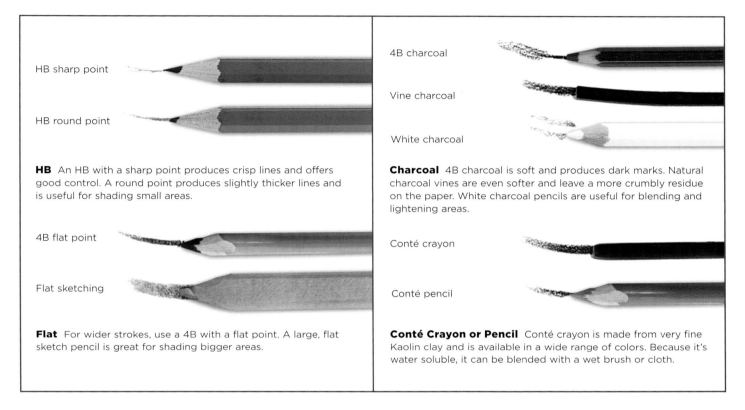

HB sharp point

HB round point

HB An HB with a sharp point produces crisp lines and offers good control. A round point produces slightly thicker lines and is useful for shading small areas.

4B flat point

Flat sketching

Flat For wider strokes, use a 4B with a flat point. A large, flat sketch pencil is great for shading bigger areas.

4B charcoal

Vine charcoal

White charcoal

Charcoal 4B charcoal is soft and produces dark marks. Natural charcoal vines are even softer and leave a more crumbly residue on the paper. White charcoal pencils are useful for blending and lightening areas.

Conté crayon

Conté pencil

Conté Crayon or Pencil Conté crayon is made from very fine Kaolin clay and is available in a wide range of colors. Because it's water soluble, it can be blended with a wet brush or cloth.

SHARPENING YOUR PENCILS

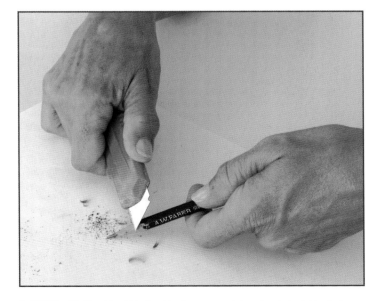

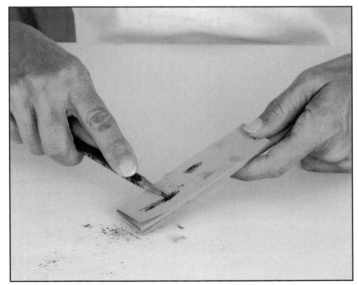

A Utility Knife Use this tool to form a variety of points (chiseled, blunt, or flat). Hold the knife at a slight angle to the pencil shaft, and always sharpen away from you, taking off a little wood and graphite at a time.

A Sandpaper Block This tool will quickly hone the lead into any shape you wish. The finer the grit of the paper, the more controllable the point. Roll the pencil in your fingers when sharpening to keep its shape even.

BASIC DRAWING TECHNIQUES

You can create a variety of effects, lines, and strokes with pencil simply by alternating hand positions and shading techniques. Many artists use two main hand positions for drawing. The writing position is good for detailed work that requires hand control. The underhand position allows for a freer stroke with arm movement and motion that is similar to painting.

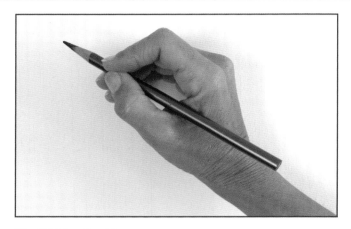

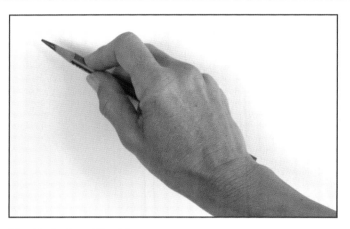

The Writing Position The writing position provides the most control in which to produce accurate, precise lines for rendering fine details and accents.

The Underhand Position Place your hand over the pencil and grasp it between the thumb and index finger. Allow your other fingers to rest alongside the pencil. This position is great for creating beautiful shading effects and long, sweeping lines.

CREATING TEXTURE

The techniques below can help you learn to render everything from a smooth complexion and straight hair to shadowed features and simple backgrounds. Whatever techniques you use, always remember to shade evenly.

Hatching This basic method of shading involves filling an area with a series of parallel strokes. The closer the strokes, the darker the tone.

Crosshatching For darker shading, place layers of parallel strokes on top of one another at varying angles. Again, make darker values by placing the strokes closer together.

Gradating To create graduated values (from dark to light), apply heavy pressure with the side of your pencil.

Shading Darkly By applying heavy pressure to the pencil, you can create dark, linear areas of shading.

Shading with Texture For a mottled texture, use the side of the pencil tip to apply small, uneven strokes.

Blending To smooth out the transitions between strokes, gently rub the lines with a tortillon or tissue.

OTHER PENCIL TECHNIQUES

Below are a few more techniques for experimenting in graphite. For these exercises, you will need hard and soft pencils, as well as a water-soluble pencil.

Creating a Graphite Wash Shade an area with a water-soluble pencil and blend the strokes with a wet brush. Always use water-soluble pencils on thick paper, such as vellum board, and avoid using too much water on the brush.

Lifting Out Blend a soft pencil on smooth paper, and then lift out the desired area with a kneaded eraser. You can create highlights and other interesting effects with this technique.

Rubbing Place paper over an object and rub the side of your pencil lead over the paper. The strokes of your pencil will pick up the pattern underneath and replicate it on the paper. Try using a soft pencil on smooth paper, and choose an object with a strong textural pattern, such as a wire grid, as shown at left.

Producing Indented Lines "Draw" a pattern or design with a sharp, non-marking object such as a knitting needle or stylus. Next, shade over the area with the side of your pencil to reveal the pattern.

Smudging

Smudging is an important technique for creating shading and gradients. Use a tortillon or chamois cloth to blend your strokes. It is important that you do not use your finger; your hands produce natural oils that can damage your artwork.

Smudging on Rough Surfaces For a granular effect, use a 6B pencil on vellum-finish Bristol board. Stroke with the side of the pencil; then blend with a tortillon.

Smudging on Smooth Surfaces Use a 4B pencil on plate-finish Bristol board. Stroke with the side of the pencil; then blend with a tortillon.

SHADING TECHNIQUES

Drawing consists of three main elements: line, shape, and form. The shape of an object can be described with a simple one-dimensional line. The three-dimensional version of the shape is known as the object's form. In pencil drawing, variations in value (the relative lightness or darkness of black or a color) describe form, giving an object the illusion of depth. Values range from black (the darkest value) through different shades of gray to white (the lightest value). To make a two-dimensional object appear three-dimensional, you must pay attention to the values of the highlights and shadows. When shading a subject, consider the light source, as this is what determines where highlights and shadows will be.

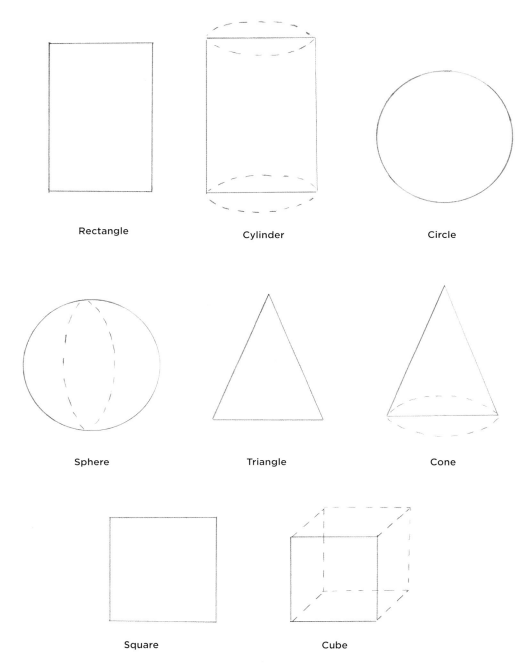

Rectangle Cylinder Circle

Sphere Triangle Cone

Square Cube

A shape can be further defined by showing how light hits the object to create highlights and shadows. First, note from which direction the source of light is coming. In these examples, the light source is beaming from the upper right.

Moving from Shape to Form The first step in creating an object is establishing a line drawing or outline to delineate the flat area that the object takes up. This is known as the "shape" of the object. The four basic shapes—the rectangle, circle, triangle, and square—can appear to be three-dimensional by adding a few carefully placed lines that suggest additional planes. By adding ellipses to the rectangle, circle, and triangle, you've given the shapes dimension and have begun to produce a form within space. Now the shapes are a cylinder, sphere, and cone. Add a second square above and to the side of the first square; then connect them with parallel lines, and you have a cube.

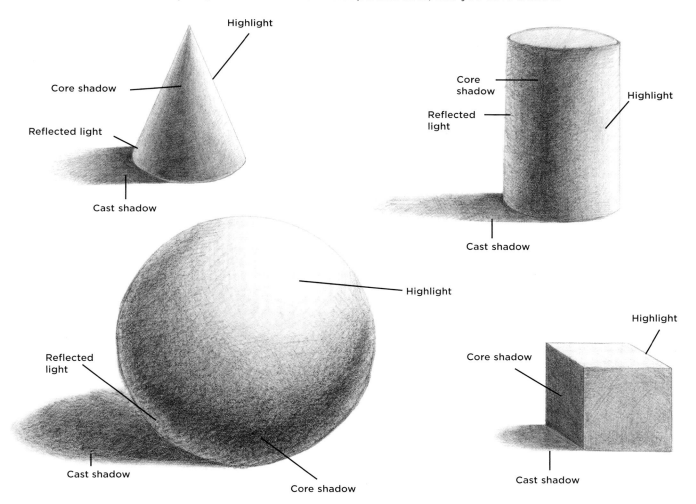

Adding Value to Create Form A shape can be further defined by showing how light hits the object to create highlights and shadows. Note from which direction the source of light is coming; then add the shadows accordingly. The core shadow is the darkest area on the object and is opposite the light source. The cast shadow is what is thrown onto a nearby surface by the object. The highlight is the lightest area on the object, where the reflection of light is strongest. Reflected light is the surrounding light reflected into the shadowed area of an object.

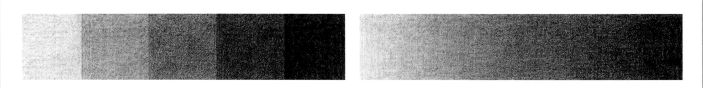

Creating Value Scales Just as a musician uses a musical scale to measure a range of notes, an artist uses a value scale to measure changes in value. You can refer to the value scale so you'll always know how dark to make your dark values and how light to make your highlights. The scale also serves as a guide for transitioning from lighter to darker shades. Making your own value scale will help familiarize you with the different variations in value. Work from light to dark, adding more and more tone for successively darker values (as shown above left); then create a blended value scale (as shown above right). You can use a tortillon to smudge and blend each value into its neighboring value from light to dark to create a gradation.

PEOPLE IN PERSPECTIVE

To practice perspective, try drawing a frontal view of many heads as if they were people sitting in a theater. Start by establishing your vanishing point at eye level (on the horizon line). Draw one large head representing the person closest to you, and use it as a reference for determining the sizes of the other figures in the drawing. Keep in mind that a composition also can have two or more vanishing points.

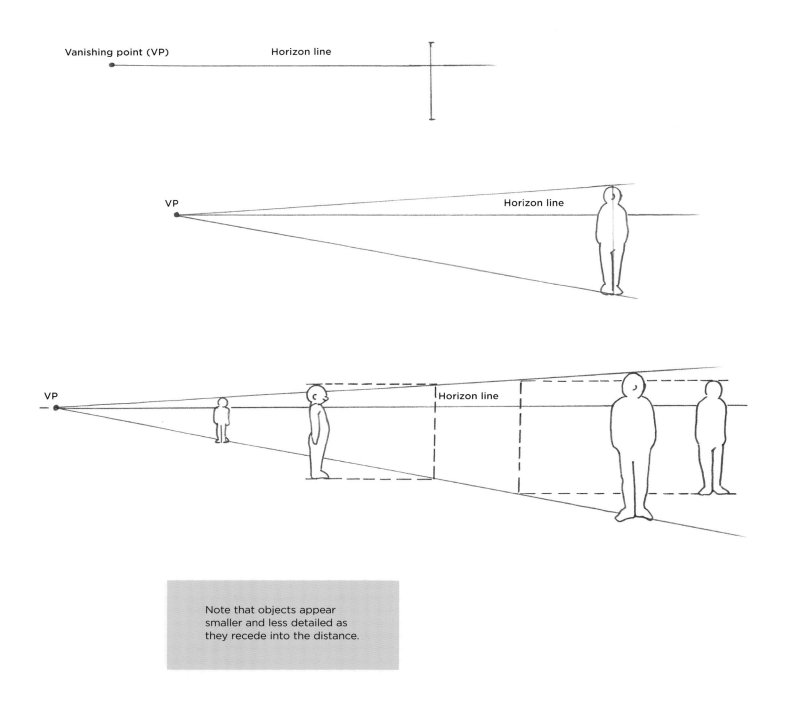

Note that objects appear smaller and less detailed as they recede into the distance.

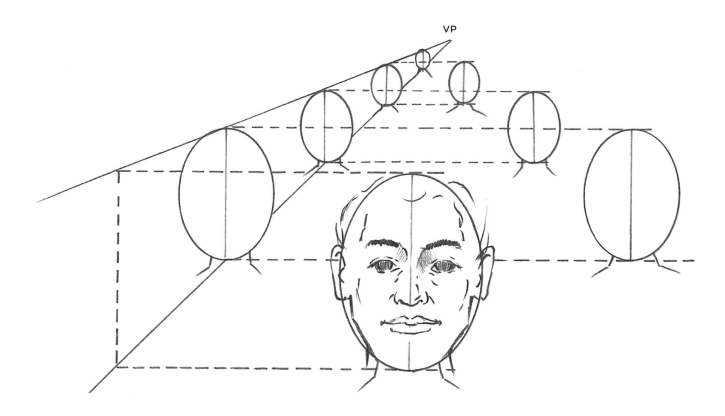

If you're a beginner, you may want to begin with basic one-point perspective, where all perspective lines meet at one vanishing point on the horizon line. As you progress, attempt to incorporate two- or three-point perspective.

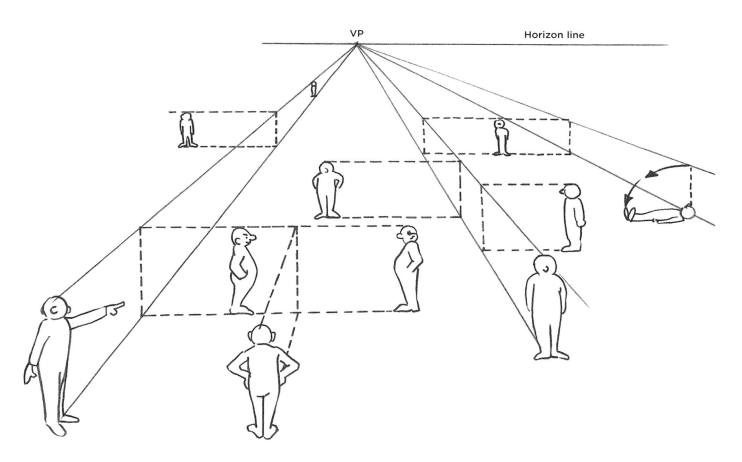

PORTRAITURE BASICS

The positioning and size of a person on the picture plane is of utmost importance to the composition. The open or "negative" space around the portrait subject generally should be larger than the area occupied by the subject. Whether you are drawing only the face, a head-and-shoulders portrait, or a complete figure, thoughtful positioning will establish a pleasing composition with proper balance.

PLACEMENT

The eyes of the subject are the key to placement. The eyes catch the viewer's attention first, so they should not be placed on either the horizontal or vertical center line of the picture plane; preferably, the eyes should be placed above the center line. Avoid drawing too near the sides, top, or bottom of the picture plane, as this gives an uneasy feeling of imbalance.

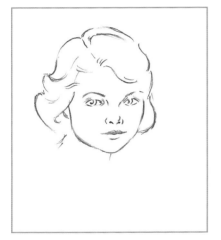

Good placement

Too far right

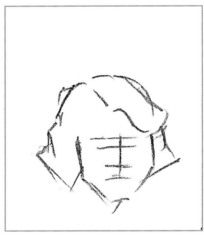

Too low

Lighting the Model

Whether you're working from life or creating a reference photo, how you light the model will play a huge role in the mood and overall success of your drawing. Below are two drawings of the same woman by artist Lance Richlin, which were completed with two different lighting styles. The side lighting (left) creates a harsher look with distinct shadows and more contrast. The front lighting (right) produces a more feminine, delicate image.

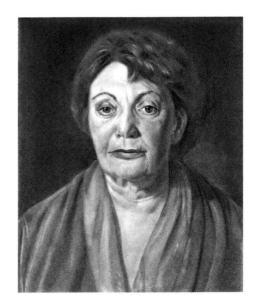

ADDING ELEMENTS TO PORTRAITS

Many portraits are drawn without backgrounds to avoid distracting the viewer from the subject. If you do add background elements to portraits, be sure to control the size, shape, and arrangement of elements surrounding the figure. Additions should express the subject's personality or interests.

Repetition of Shapes within the Portrait
The delicate features of this young woman are emphasized by the simple, abstract elements in the background. The flowing curves fill much of the negative space, while accenting the elegance of the woman's hair and features. Simplicity of form is important in this composition; the portrait highlights only her head and neck. Notice that her eyes meet the eyes of the viewer—a dramatic and compelling feature.

Depicting the Subject's Interest This portrait of a young man includes a background that shows his interest in rocketry. The straight lines in the background contrast the rounded shapes of the human form. Although the background detail is complex, it visually recedes and serves to balance the man's weight. The focus remains on the man's face.

LEARNING TO "SEE"

Many beginners draw without really looking carefully at their subject; instead of drawing what they actually see, they draw what they think they see. Try drawing something you know well, such as your hand, without looking at it. Chances are your finished drawing won't look as realistic as you expected. That's because you drew what you think your hand looks like. Instead, you need to forget about all your preconceptions and learn to draw only what you really see. The following contour drawing exercises are great for training your eye and hand to work together to represent what is truly in front of you.

CONTOUR DRAWING

In contour drawing, you pick a starting point on your subject and then draw only the contours—or outlines—of the shapes you see. Because you're not looking at your paper, you're training your hand to draw the lines exactly as your eye sees them. Try doing some contour drawings of your own; you'll be surprised at how well you're able to capture the subjects.

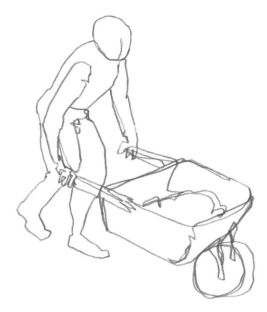

Drawing with a Continuous Line When drawing this figure, glance only occasionally at your paper to check that you are on track. Concentrate on looking at the subject and tracing the outlines you see. Do not lift your pencil between shapes; keep the lines unbroken by freely looping back and crossing over previous lines. This simple technique effectively captures the subject.

Drawing "Blind" For the contour drawing on the left, the artist occasionally looked down at the paper. The drawing on the right is an example of a blind contour drawing, where the artist drew without looking at his paper even once. It's a little distorted, but it's clearly a hand. Blind contour drawing is one of the best ways of making sure you're truly drawing only what you see.

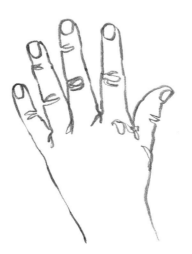
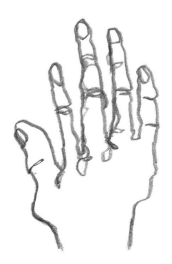

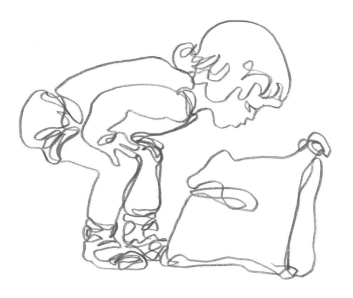

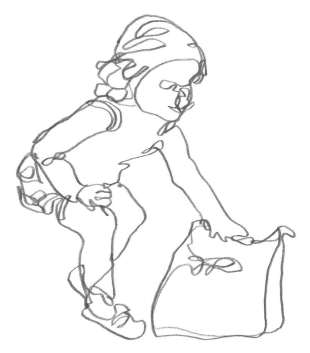

Action Once you have trained your eye to observe carefully and can draw quickly, you'll be able to capture actions such as this child looking and then reaching into the bag.

Transferring an Image

A quick way to achieve an accurate drawing, without the initial stages of sketching, is to transfer the main lines of a photographic reference onto your drawing paper. First, print out your reference at the size you plan to draw it. Then place a sheet of tracing paper over the printout and trace the outlines. Coat the back of the tracing paper with an even layer of graphite and place it over a clean sheet of drawing paper, graphite-side down. (Instead of coating the back of the tracing paper, you might choose to purchase and use transfer paper, which already has one side coated with graphite.) Tape or hold the papers together and lightly trace your outlines with a ballpoint pen or stylus. The lines of your tracing paper will transfer to the drawing paper below.

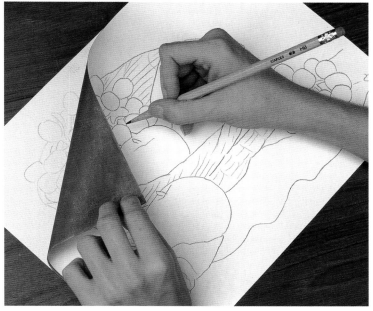

While tracing the lines, occasionally lift the corner of the sketch (and the transfer paper, if present) to make sure the lines that have transferred aren't too light or too dark.

BASIC ANATOMY

In this section you will learn the skeletal and muscular structure of the torso, arms, legs, hands, feet, head, and face. Knowing what lies beneath the skin will help you draw more accurate portraits.

FRONT TORSO

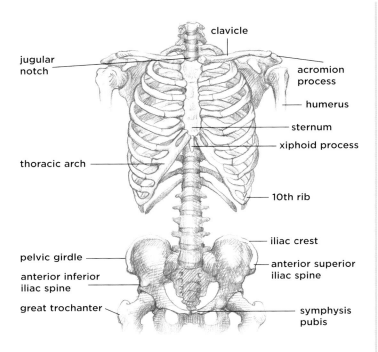

Skeleton Some parts of the skeletal system are important to the artist because they are prominent and serve as visual landmarks. Several bones of the torso's frontal skeleton are obvious even beneath the skin.

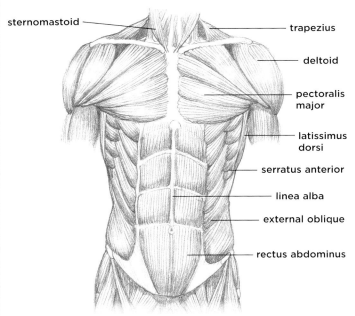

Trunk Muscles The torso's movement is dependent on and restricted by the spine; both the chest and the pelvis twist and turn on this fixed, yet flexible, column. And the relationship between the rib cage, the shoulders, and the pelvis creates the shape of the trunk muscles.

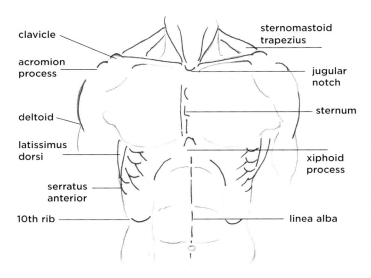

Diagram of Landmarks The observable muscles and bony landmarks labeled on the illustration above are the most important for artists who want to draw the torso's surface anatomy from the front view.

Drawing Tips Use the bony skeletal landmarks, which are apparent despite the layers of muscles, to guide the placement of the features.

22

BACK TORSO

Skeleton The back is one of the most challenging parts of the body to draw because of its skeletal and muscular complexity.

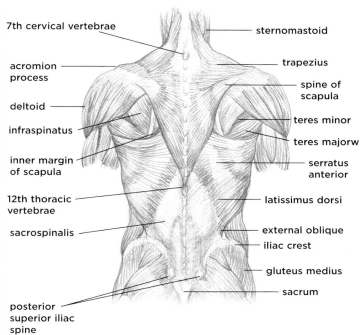

Trunk Muscles The back has many overlapping muscles; our focus will be on the upper layer, which is more immediately apparent to the eye.

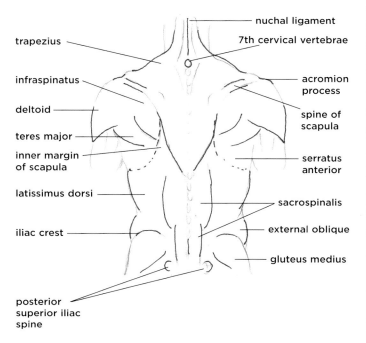

Diagram of Landmarks The observable muscles and bony landmarks labeled on the illustration above are the most important for artists who want to draw the torso's surface anatomy from the rear view.

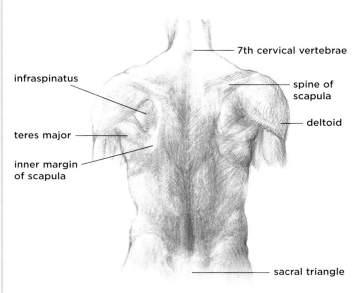

Drawing Tips Under the skin, back muscles are not easy to discern. However, the *trapezius, 7th cervical vertebrae, spine of scapula, inner margin of scapula, deltoid, infraspinatus,* and *teres major* are all fairly evident.

ARMS & HANDS

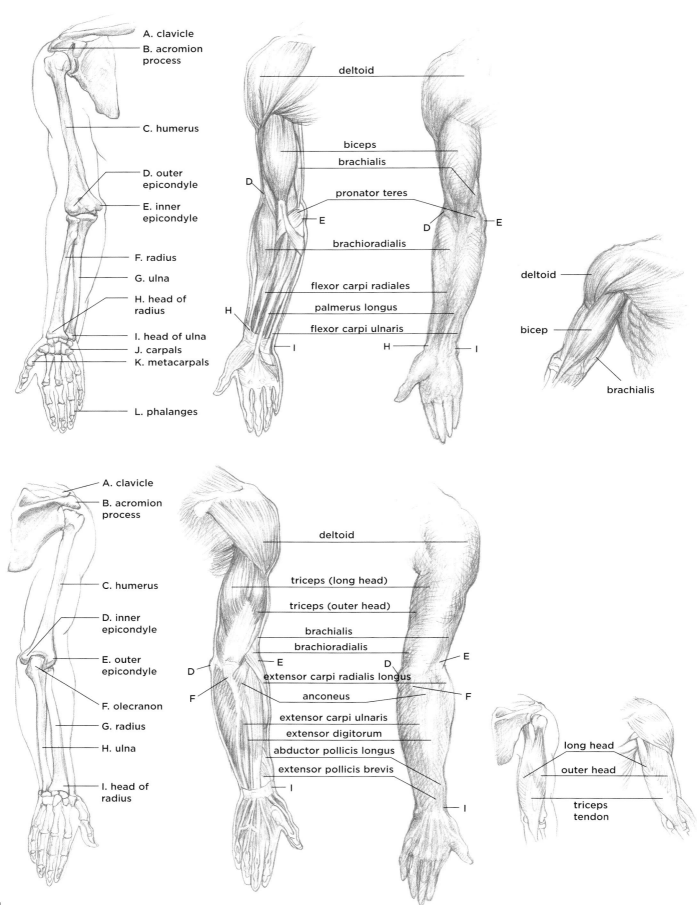

A. clavicle
B. acromion process
C. humerus
D. outer epicondyle
E. inner epicondyle
F. radius
G. ulna
H. head of radius
I. head of ulna
J. carpals
K. metacarpals
L. phalanges

deltoid
biceps
brachialis
pronator teres
brachioradialis
flexor carpi radiales
palmerus longus
flexor carpi ulnaris

deltoid
bicep
brachialis

A. clavicle
B. acromion process
C. humerus
D. inner epicondyle
E. outer epicondyle
F. olecranon
G. radius
H. ulna
I. head of radius

deltoid
triceps (long head)
triceps (outer head)
brachialis
brachioradialis
extensor carpi radialis longus
anconeus
extensor carpi ulnaris
extensor digitorum
abductor pollicis longus
extensor pollicis brevis

long head
outer head
triceps tendon

CLENCHED FIST

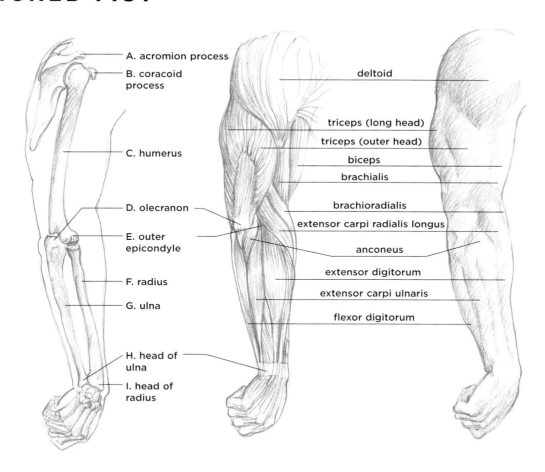

A. acromion process
B. coracoid process
C. humerus
D. olecranon
E. outer epicondyle
F. radius
G. ulna
H. head of ulna
I. head of radius

deltoid
triceps (long head)
triceps (outer head)
biceps
brachialis
brachioradialis
extensor carpi radialis longus
anconeus
extensor digitorum
extensor carpi ulnaris
flexor digitorum

Drawing Tips

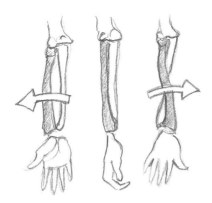

Rotated arm The *brachioradialis* is responsible for turning the palm up *(supinate)*, and the *pronator teres* for turning the palm down *(pronate)*. The *radius* (shaded) rotates around the fixed *ulna*, permitting pronation and supination of the palm.

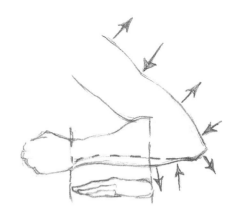

Bent arm The span between the inside bend of the elbow and the wrist is usually about one hand length. The arrows show the inward and outward curvature of the muscles, and the dashed line shows the line of the *ulna*, called the "ulnar furrow."

LEGS & FEET

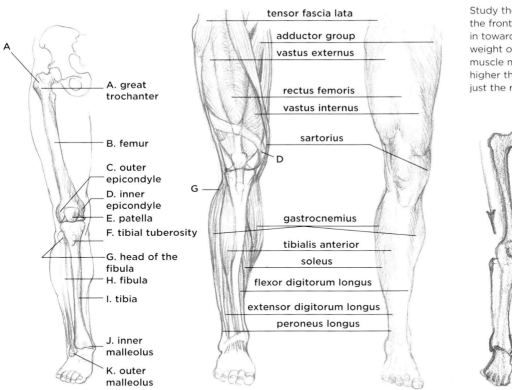

A. great trochanter
B. femur
C. outer epicondyle
D. inner epicondyle
E. patella
F. tibial tuberosity
G. head of the fibula
H. fibula
I. tibia
J. inner malleolus
K. outer malleolus

tensor fascia lata
adductor group
vastus externus
rectus femoris
vastus internus
sartorius
gastrocnemius
tibialis anterior
soleus
flexor digitorum longus
extensor digitorum longus
peroneus longus

Study the bones and muscles of the leg in the front view. You'll see that the legs angle in toward the middle, positioning the body's weight over the gravitational center. The muscle masses on the outside of the leg are higher than those on the inside. The ankles are just the reverse—high inside, low outside.

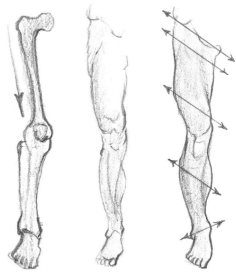

From the back view, the same leg bones that appear in the front view are visible. Their appearance is slightly altered, however, because the bone attachments in the front are designed to allow muscles to extend, and the back attachment is designed for muscles to flex. The upper leg and lower leg each features five masses. When drawing the back of the leg, notice the hollow area behind the knee where the calf tendons attach, and the calf is lower and rounder on the inside than it is on the outside.

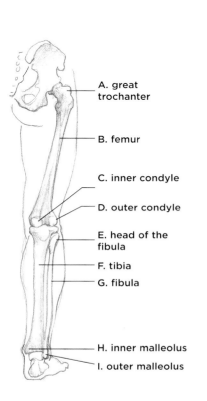

A. great trochanter
B. femur
C. inner condyle
D. outer condyle
E. head of the fibula
F. tibia
G. fibula
H. inner malleolus
I. outer malleolus

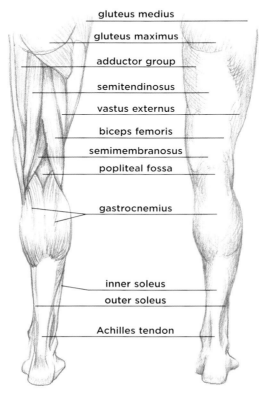

gluteus medius
gluteus maximus
adductor group
semitendinosus
vastus externus
biceps femoris
semimembranosus
popliteal fossa
gastrocnemius
inner soleus
outer soleus
Achilles tendon

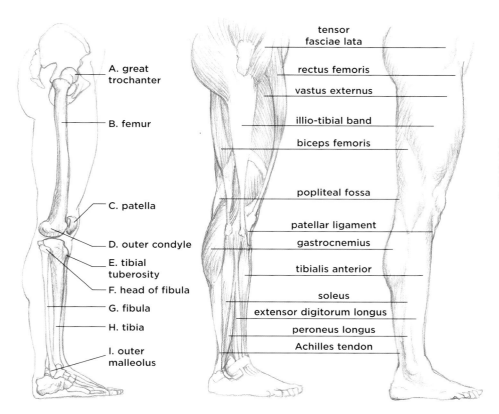

A. great trochanter

B. femur

C. patella

D. outer condyle

E. tibial tuberosity

F. head of fibula

G. fibula

H. tibia

I. outer malleolus

tensor fasciae lata

rectus femoris

vastus externus

illio-tibial band

biceps femoris

popliteal fossa

patellar ligament

gastrocnemius

tibialis anterior

soleus

extensor digitorum longus

peroneus longus

Achilles tendon

Because the long femur (B), and large tibia (H) carry the weight of the body, they sit directly on top of each other. But in a side-view drawing, the upper and lower leg appear staggered.

Drawing Tips

The six arrows in figure 1 show the overall gesture of the leg. The upper thigh and lower calf create the gesture (figure 2). Figure 3 shows the pattern of tendons in the foot.

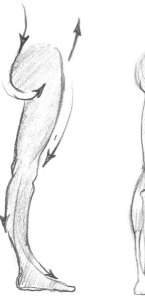

Figure 1

Figure 2

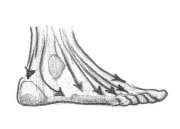

Figure 3

OPEN PALM

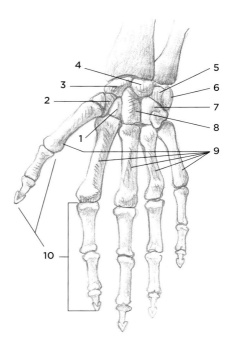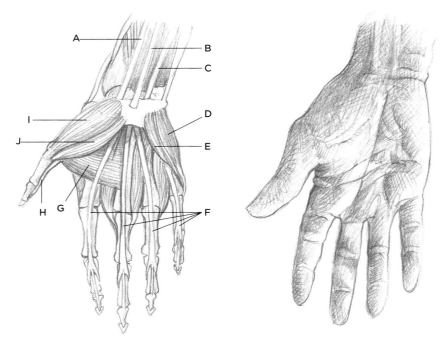

Bones The hand contains 8 wrist *(carpal)* bones: *minor multangular* (1), *major multangular* (2), *navicular* (3), *lunate* (4), *triquetrum* (5), *pisiform* (6), *hamate* (7), and *capitate* (8). The hand also features 5 *metacarpals* (9) and 14 *phalanges* (10).

Muscles The *flexor tendons* (A, B, C) from the forearm muscles extend into the hand. The teardrop-shaped muscle masses, the *thenar eminence abductors* of the thumb (I, J) and the *hypothenar eminence abductor* (D) and *flexor* (E) of the little finger, are known as the "palmer hand muscles." The *adductor* of the thumb (G) lies under the *flexor tendons* (F). The visible creases of the palm result from the way the skin folds over the fat and muscles of the hand.

BACK OF HAND

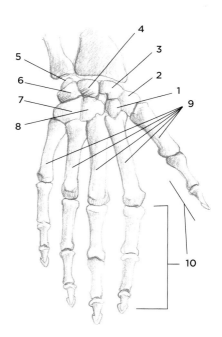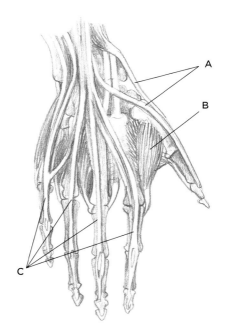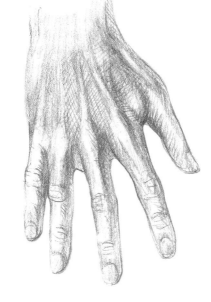

Bones From this view of the hand, all the same bones are visible, but the carpal bones appear convex rather than concave. From this angle, the bones have more influence on the shape of the fleshed-out hand.

Muscles Whereas the palm side of the hand is muscular and fatty, the back of the hand is bony and full of tendons. The *extensor tendons* of the thumb (A) are visible when contracted, as are the other four *extensor tendons* (C). The first *dorsal interosseous* (B) is the largest of the four *dorsal interosseous* muscles, and it is the only one that shows its form through the skin's surface; when the thumb is flexed, this muscle appears as a bulging teardrop shape.

TOP OF FOOT

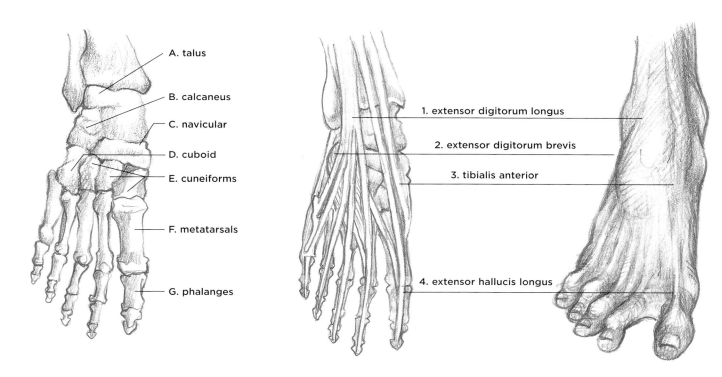

A. talus
B. calcaneus
C. navicular
D. cuboid
E. cuneiforms
F. metatarsals
G. phalanges

1. extensor digitorum longus
2. extensor digitorum brevis
3. tibialis anterior
4. extensor hallucis longus

SIDE OF FOOT

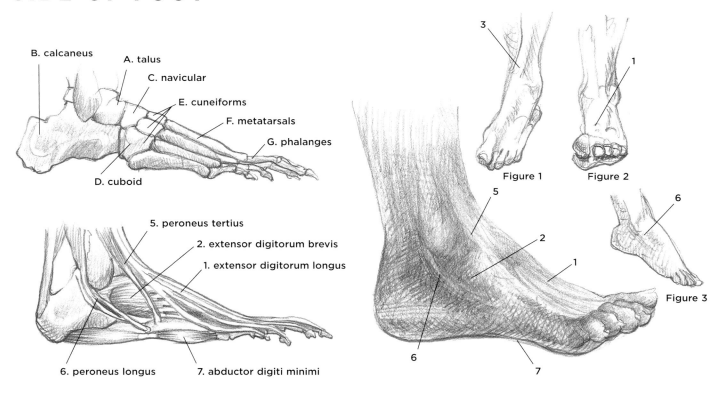

B. calcaneus
A. talus
C. navicular
E. cuneiforms
F. metatarsals
G. phalanges
D. cuboid

5. peroneus tertius
2. extensor digitorum brevis
1. extensor digitorum longus
6. peroneus longus
7. abductor digiti minimi

Figure 1
Figure 2
Figure 3

Like the hand, the foot also comprises three parts: 7 tarsal bones (A–E), 5 metatarsals (F), and 14 phalanges (G). When the foot is flexed upward, many tendons are evident. When drawing the foot, note that the tibialis anterior (3) is an obvious landmark on the inverted foot. (See figure 1, above.) In figure 2, dorsi-flexion makes visible the extensor digitorum (1). In figure 3, plantar-flexion lets you see the tendons of peroneus (6).

ADULT HEAD & FACIAL ANATOMY

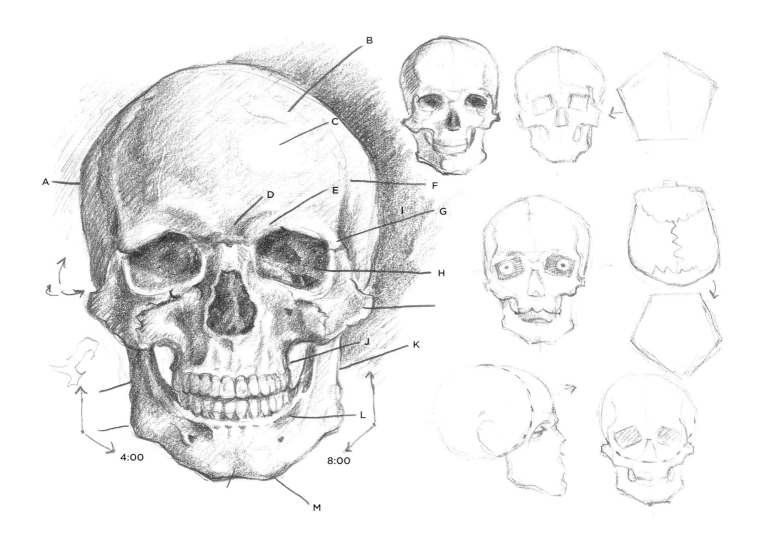

Becoming familiar with the head and skull is an excellent way to improve your portraiture skills. If you purchase a plastic skull, you can practice drawing the skull from all angles, as shown in the charcoal pencil studies above. Start with an outline of the basic shape of the skull; then block in the shapes of the main features and refine the lines (shown in the upper-right corner). The important skull bones for an artist to know are the *parietal eminence* (A), *frontal bone* (B), *frontal eminence* (C), *glabella* (D), *superciliary crest* or "brow ridge" (E), *temporal line* (F), *zygomatic process* (G), *orbit* (H), *zygomatic bone* (I), *maxilla* (J), *ramus of mandible* (K), *mandible* (L), and *mental protuberance* (M).

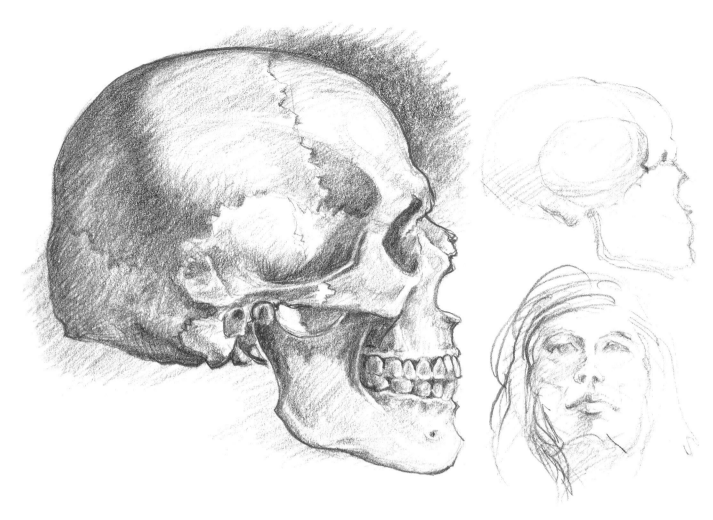

As you build your knowledge of the skull's form, work on understanding how these underlying structures shift in relation to each other as you change your viewpoint. If you have a model skull, tilt it and practice sketching it from various angles. Or use a live model to demonstrate some extreme poses.

As a subject lifts the chin, the tip of the nose becomes much closer to the eyes.

Notice how the brow appears to round as the subject moves the head downward. The eyes are positioned on an arc.

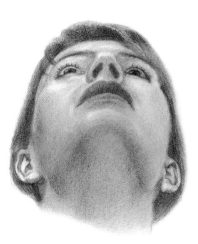

From this angle, the outer corners of the eyes are lower than the inner corners.

Front View

Side View

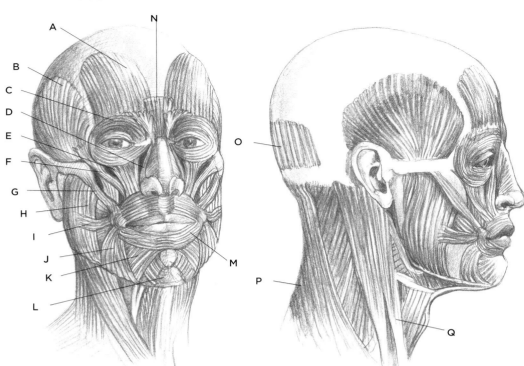

A. frontalis
B. temporalis
C. obicularis oculi
D. nasalis
E. levator labii superioris
F. zygomaticus minor
G. zygomaticus major
H. masseter
I. risorius
J. depressor anguli oris
K. depressor labii inferioris
L. mentalis
M. obicularis oris
N. procerus
O. occipitalis
P. trapezius
Q. sternocleidomastoid

Most of the facial muscles originate from bone and insert into muscle fibers of other facial muscles. They do not create surface form directly, as the skeletal muscles do, because they are much more delicate and usually concealed by facial fat. The visible forms on the face are created by several factors—skin, fatty tissue, underlying skull, cartilage, eyeballs, and some muscles.

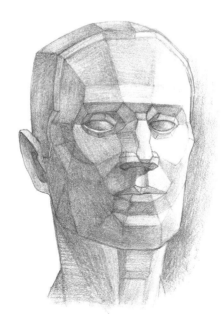

Simplifying the Features When facial muscles contract, they affect the shape of the fatty forms, skin, and other facial muscles, causing the wrinkles, furrows, ridges, and bulges that convey various facial expressions. Simplifying these complex shapes into easily recognizable geometric planes (the "planes of the head") can help guide an artist in the proper placement of light and shadow. As an artist, there's no need to actually sketch the planes, but it helps to understand the planes and visualize them when approaching complex features and shading.

Visualizing Light and Shadow In this final stage, light and shadow are translated from simple planes onto a more subtle, realistic portrait. Self-portraiture is a great way to practice identifying the planes of the head from many different angles. Using a mirror as reference, focus on the placement of the light and dark values that create the form of your face. Just remember to draw what you really see in the mirror, not what you expect to see.

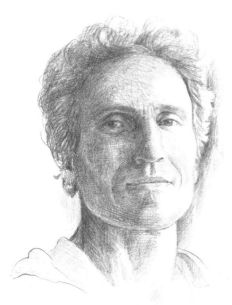

ADULT FACIAL FEATURES

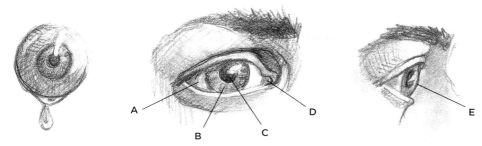

Drawing Tips The *sclera* (A) is the white of the eye. The *iris* (B) is a colored disc that controls the amount of light entering the round opening of the *pupil* (C). The domelike, transparent *cornea* (E) sits over the *iris.* The *inner canthus* (D) at the corner of the eye is an important feature of the shape of the eye.

The Eye The eyeball is a moist sphere. Because its surface is glossy, the *cornea* (E) often features a highlight.

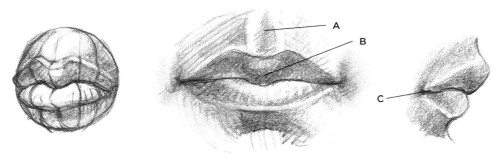

Drawing Tips The vertical furrow between the nose and upper lip is the *philtrum* (A). The *tubercle* (B) of the upper lip is a small rounded form surrounded by two elongated forms; it fits into the middle of the two elongated forms of the lower lip. The *node* (C) is an oval muscular form on the outer edge of the mouth.

The Lips Because the lips curve around the cylinder of the teeth, it's helpful to draw and shade the mouth as if it were a sphere.

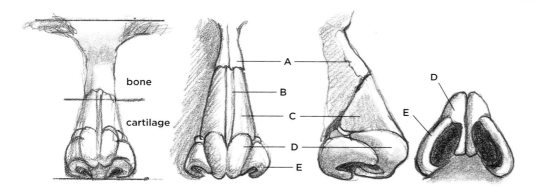

Drawing Tips The bridge of the nose is formed by two *nasal bones* (A). The middle section of the nose is made of a rigid *septal cartilage* (B), surrounded by two *lateral cartilages* (C). The bulb of the nose is formed by two *greater alar cartilages* (D). Two *wings* (E) create the nostrils.

The Nose The nose is made up of bone, cartilage, and fatty tissue. Halfway down from the eyebrows, cartilage replaces the bone.

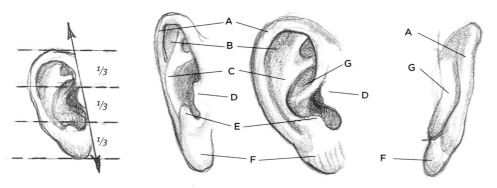

Drawing Tips The cartilaginous *helix* (A) forms the outer rim of the ear. The *antihelix* (C) lies just inside the *helix,* running roughly parallel to it; the two are divided by the *scapha* (B). The *tragus* (D) is a cartilaginous projection, located over the bowl (the *concha,* G). The *antitragus* (E) is located opposite the *tragus* and just above the fatty *lobe* (F).

The Ear Think of the ear as an oval disc divided into three sections and placed on a diagonal angle.

CHILD ANATOMY

Children's proportions are different than those of adults. As they grow, the facial features and body proportions change. Young children's heads are larger in proportion to their bodies, and the placement of the features changes as the face becomes longer and thinner with age.

CHILD HEAD & FACIAL PROPORTIONS

Young children have rounder faces with larger eyes that are spaced farther apart. Their features also are positioned a little lower on the face; for example, the eyebrows begin on the centerline, where the eyes would be on a teenager or an adult. As a child ages, the shape of the face elongates, altering the proportions.

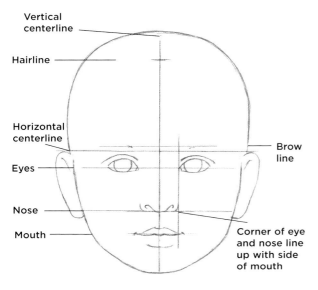

Vertical centerline

Hairline

Horizontal centerline

Eyes

Nose

Mouth

Brow line

Corner of eye and nose line up with side of mouth

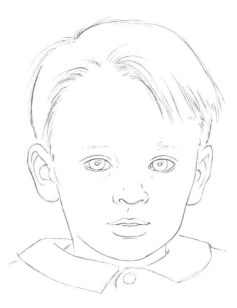

Placing the Features Based on the placement of this subject's features, you can estimate that he is around five or six years old. The face has elongated enough to shift the brow line so that it lines up with the tops of the ears, showing that the child is no longer a baby. But the eyes are spaced farther apart, indicating youth. The mouth is still relatively close to the chin, which also emphasizes his young age.

Changing Over Time

Use horizontal guidelines to divide the area from the horizontal centerline to the chin into equal sections; these lines can then be used to determine where to place the facial features.

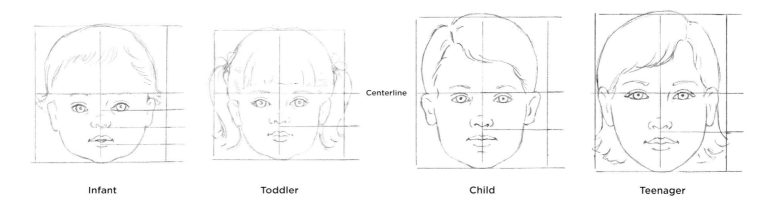

Centerline

Infant Toddler Child Teenager

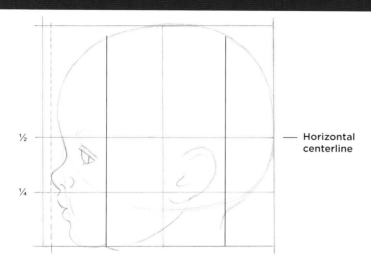

— Horizontal centerline

½

¼

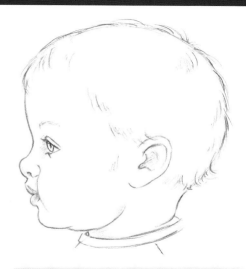

Drawing a Baby in Profile The profile of a child usually is very rounded. Youngsters generally have bigger, more protruding foreheads than adults do. And children's noses tend to be smaller and more rounded, as well. The shape of a baby's head in profile also fits into a square. Block in the large cranial mass with a circle; then sketch the features. The brow line is at the horizontal centerline, whereas the nose is about one-fourth of the way up the face.

Light eyebrows and wispy hair help indicate a baby's age; as children get older, their hair grows in thicker.

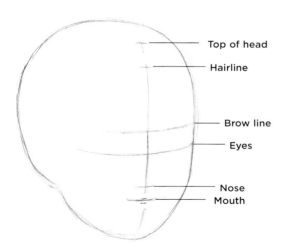

— Top of head

— Hairline

— Brow line

— Eyes

— Nose
— Mouth

Adding Children's Details The features shift slightly in a three-quarter view, as shown here. Although a baby's features are placed differently on the head than an older child's are, their facial guidelines shift similarly, following the direction in which the head turns. Place the features according to the guidelines. Hair style and clothing—including accessories—also can influence the perceived age of your subject.

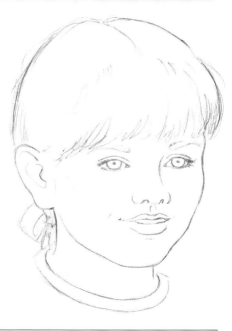

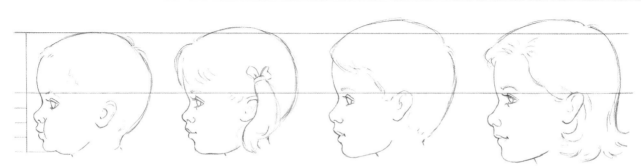

Modifying the Profile

As children age, their profiles change quite a bit. The head elongates at each stage; the top of the baby's eyebrow lines up with the bottom of the toddler's eyebrow, the midway point between the young boy's eyebrow and eyelid, and the top of the teenage girl's eyelid.

CHILD BODY PROPORTIONS

The heads and bodies of children differ from those of adults in both size and *proportion* (or the relative size of body parts to each other). Accurate proportions are the foundation of expressing age in a drawing. The illustrations below demonstrate how to use the size of the head as a measuring unit for drawing children of various ages. If you're observing your own model, measure exactly how many heads make up the height of the subject's actual body.

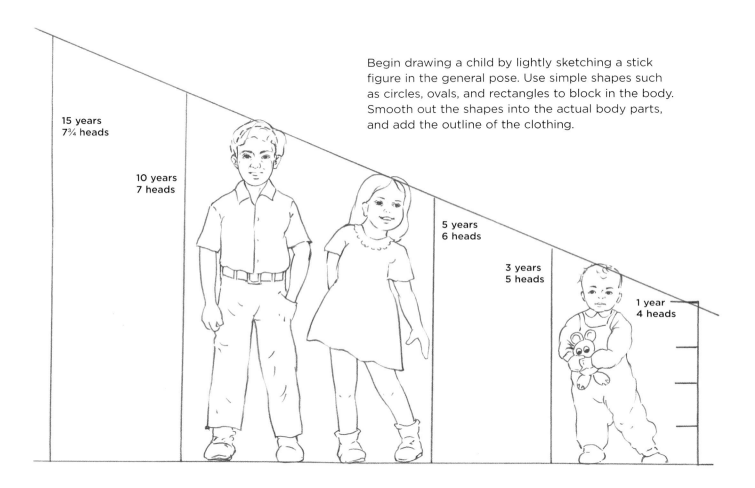

Begin drawing a child by lightly sketching a stick figure in the general pose. Use simple shapes such as circles, ovals, and rectangles to block in the body. Smooth out the shapes into the actual body parts, and add the outline of the clothing.

15 years
7¾ heads

10 years
7 heads

5 years
6 heads

3 years
5 heads

1 year
4 heads

Children are great fun to draw, but because they generally don't remain still for long periods, start out using photographs instead of live models.

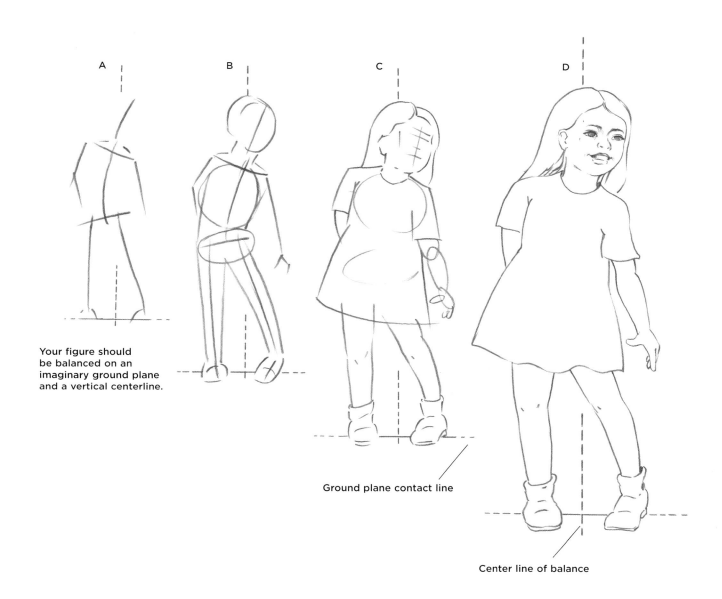

A B C D

Your figure should
be balanced on an
imaginary ground plane
and a vertical centerline.

Ground plane contact line

Center line of balance

A wide stance is a common trait of children's poses. To keep your youthful
subject from appearing off-kilter, it's a good idea to build the figure around
a center of balance.

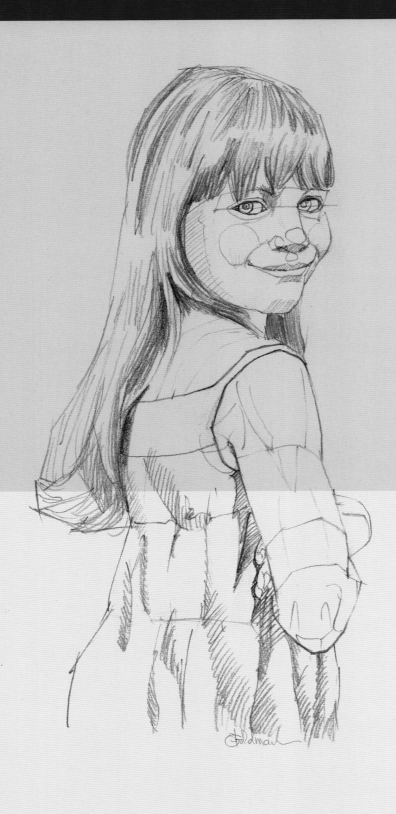

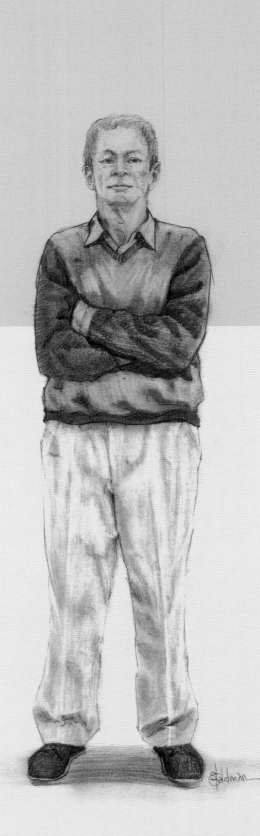

Chapter 2

BASIC POSES

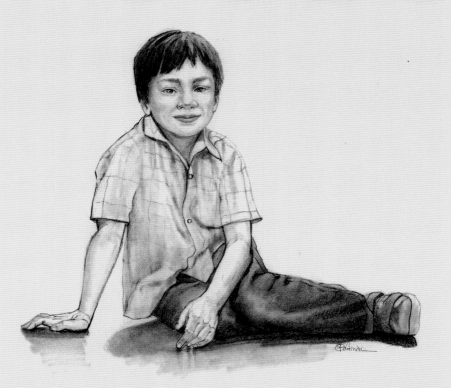

STANDING POSES

When drawing the figure in any pose, one of the most important things to account for is the body's center of gravity. As you study the upright standing poses in this section, keep this in mind and look for the subtle shifts and changes in stature. Without knowing where the center of gravity falls, it can be easy to misplace, which results in the body appearing off balance.

WIDE STANCE

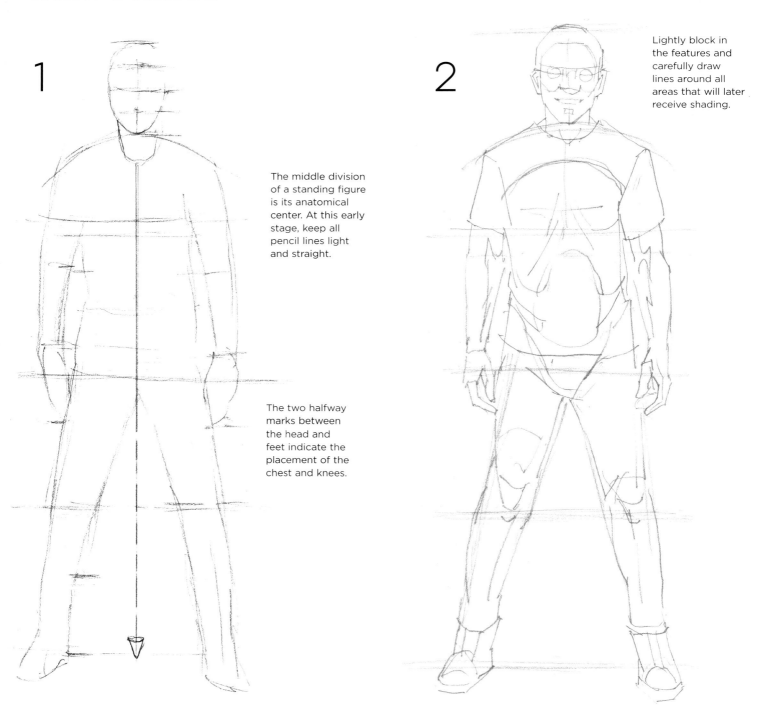

1

The middle division of a standing figure is its anatomical center. At this early stage, keep all pencil lines light and straight.

The two halfway marks between the head and feet indicate the placement of the chest and knees.

2

Lightly block in the features and carefully draw lines around all areas that will later receive shading.

3

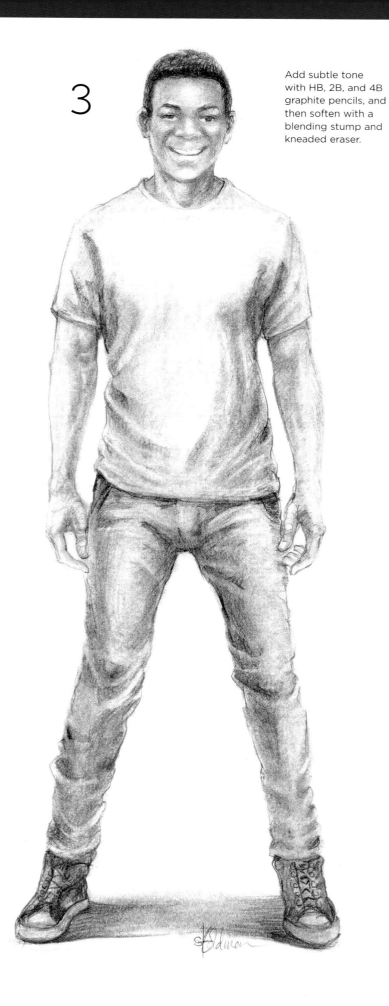

Add subtle tone with HB, 2B, and 4B graphite pencils, and then soften with a blending stump and kneaded eraser.

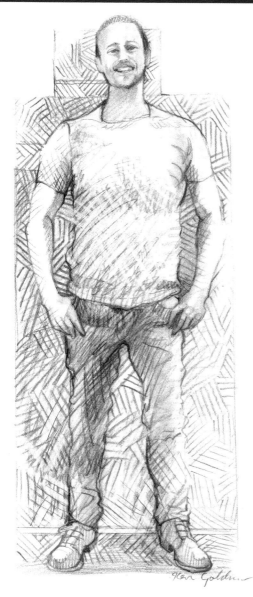

Similar to the wide-leg stance, this pose requires a little less laying in at the onset. Add textures to the background and light and dark lines around the figure to invigorate the drawing. Notice the slight variation, as the subject gently hooks his thumbs in his front pockets.

Two-dimensional shapes transform into three-dimensional figures with the help of shading. The values are what give the anatomy shape and the impression of light falling across the figure. Don't overthink the process; instead of viewing legs and ribs, think about the smaller shapes created by light and shadow, adding them one value at a time.

HANDS ON HIPS

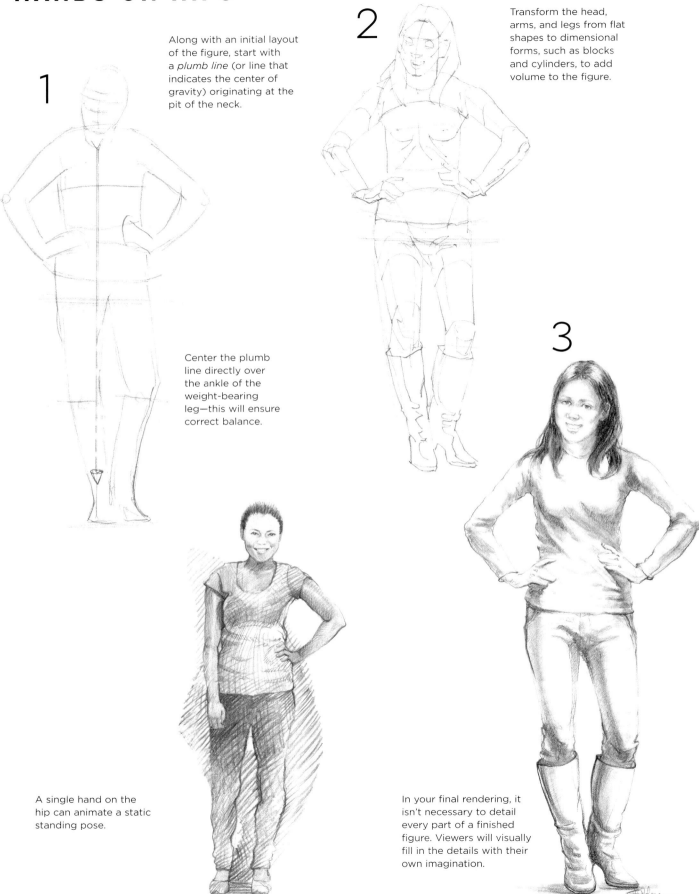

1 Along with an initial layout of the figure, start with a *plumb line* (or line that indicates the center of gravity) originating at the pit of the neck.

Center the plumb line directly over the ankle of the weight-bearing leg—this will ensure correct balance.

2 Transform the head, arms, and legs from flat shapes to dimensional forms, such as blocks and cylinders, to add volume to the figure.

3

A single hand on the hip can animate a static standing pose.

In your final rendering, it isn't necessary to detail every part of a finished figure. Viewers will visually fill in the details with their own imagination.

ARMS CROSSED

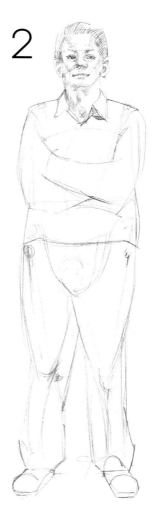

1

When drawing a figure with crossed arms, begin by lightly sketching a box-like shape for the arms. Construct two opposing triangles for the torso, and mark the location of the shoulders, crotch, and knees. Additionally, locate divisions for the facial features.

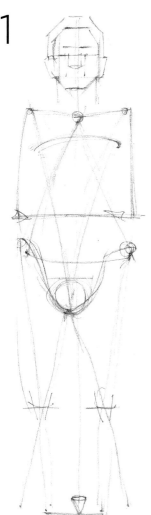

2

3

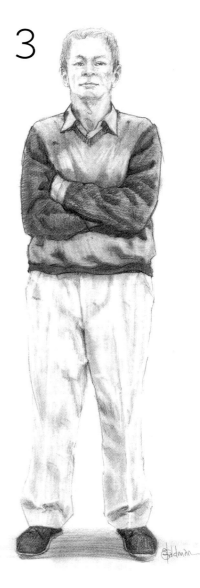

In order to bring more attention to the upper body, crosshatch dark strokes into the dark pants without losing the legs' gesture.

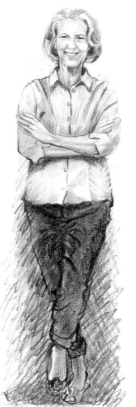

Although your earlier construction lines are now covered up during the rendering process, notice how important those earlier marks were in the underlying features, torso, crotch, and knees. All final details rely on a careful initial lay-in.

LOOKING BACK

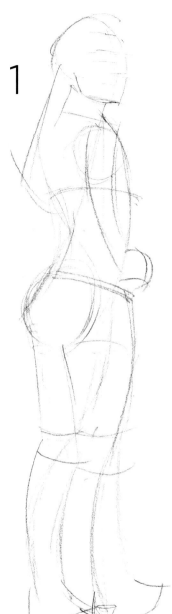

1

In this position, the figure's arm and shoes are foreshortened. Draw these shapes by looking at the negative space around them.

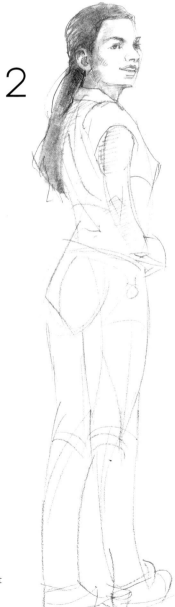

2

After the figure is carefully blocked in, render the head first. The darks in the hair and eyes will set the value scale for the rest of the drawing.

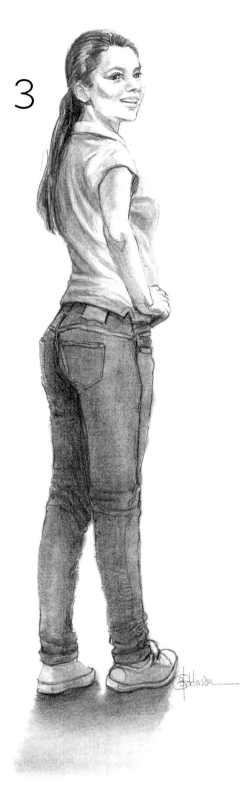

3

When you accurately draw the negative shapes at the beginning, added details and shading turn these carefully drawn two-dimensional shapes into believable three-dimensional forms.

FROM THE SIDE

1

Use lightly curved gesture lines to create a foundation of graceful movement for the early stage of this pose.

Note the plumb line that drops directly from the pit of the neck over the weight-bearing ankle.

2

The head is almost always the best place to begin a drawing, before you attempt to finalize body proportions.

Once you're certain about head size, the head becomes a standard for all further body measurements.

3

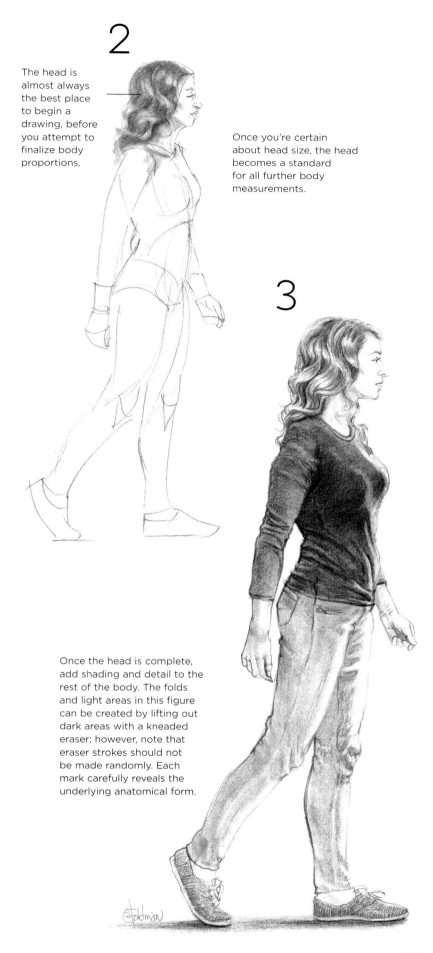

Once the head is complete, add shading and detail to the rest of the body. The folds and light areas in this figure can be created by lifting out dark areas with a kneaded eraser; however, note that eraser strokes should not be made randomly. Each mark carefully reveals the underlying anatomical form.

When drawing hands, be sure the fingers taper gracefully from thick to thin, particularly on feminine figures.

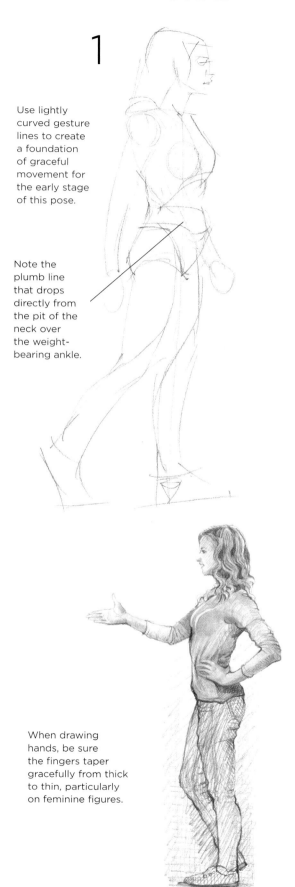

LEANING FORWARD

1

Draw the feet as triangular-shaped wedges and the top of the shoulders as an oval. Because the viewer's eye level is higher than this child, it's important to indicate the top planes and correct perspective right from the start.

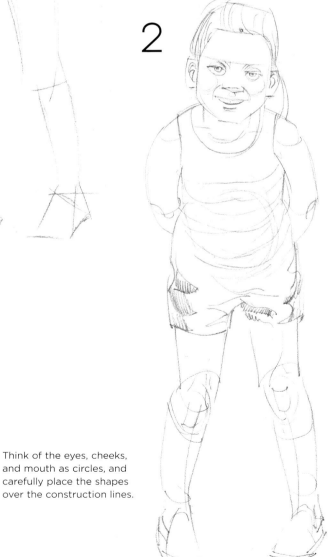

2

Think of the eyes, cheeks, and mouth as circles, and carefully place the shapes over the construction lines.

3

Use a 2B pencil, kneaded eraser, and blending stump to transform the facial construction circles into detailed eyes, cheeks, nose, and mouth. Note how the rounded stripes on the shirt enhance the sense of a bird's-eye-view perspective.

STEPPING FORWARD

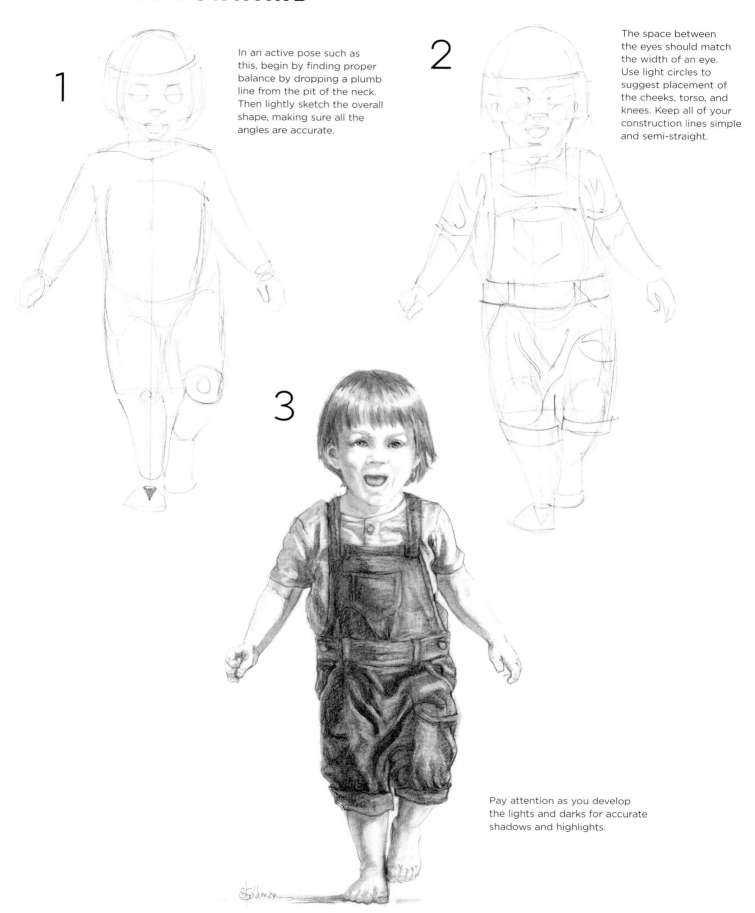

1

In an active pose such as this, begin by finding proper balance by dropping a plumb line from the pit of the neck. Then lightly sketch the overall shape, making sure all the angles are accurate.

2

The space between the eyes should match the width of an eye. Use light circles to suggest placement of the cheeks, torso, and knees. Keep all of your construction lines simple and semi-straight.

3

Pay attention as you develop the lights and darks for accurate shadows and highlights.

CASUAL STANDING POSITIONS

By simply placing one foot forward, a static pose becomes more active.

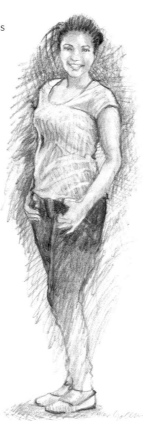

The model in this pose has a smile worth accentuating. Blending her dark hair into the background brings out her smile.

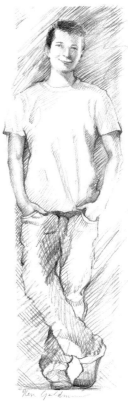

To add more interest to this casual pose, vary the line directions and add a darker double-line to the rear leg.

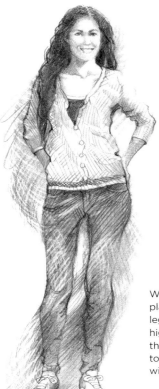

When weight is placed on the left leg, the left hip goes higher. To maintain this balance, the torso compensates with a counter-tilt.

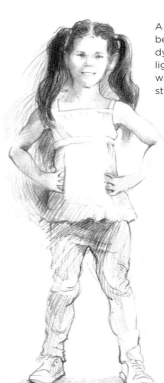

A static pose becomes more dynamic by using light and dark lines with varied vigorous strokes.

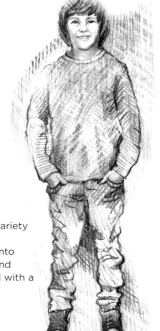

Add more variety by stroking diagonally into the figure and background with a vinyl eraser.

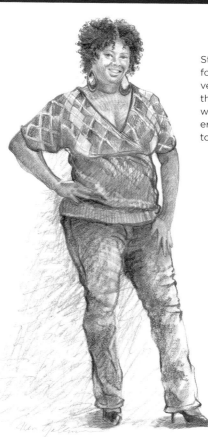

Stroke directions should follow forms. Note how vertical pencil lines follow this woman's cheek plane, while vertical and diagonal eraser strokes describe her torso and chest.

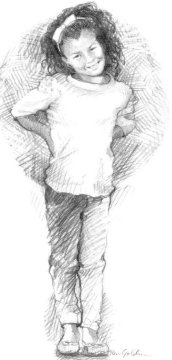

The tilt of this young girl's head highlights her perky personality. The circular cross-hatched background emphasizes her straight, erect posture.

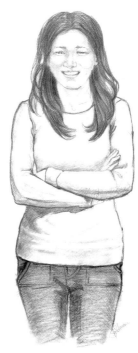

There is a strong cast shadow under the arms. Here is an important cast shadow rule: It always becomes lighter and softer at the edges as it leaves its source.

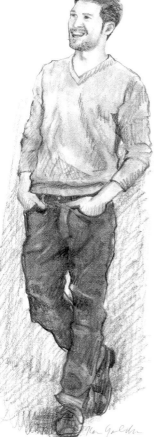

A wide range of values from light to dark creates visual excitement.

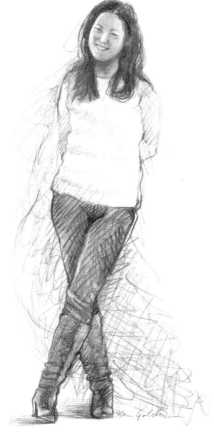

Crossed legs and extreme contrast between the model's dark hair and white shirt are two of the main reasons this pose appears so dynamic.

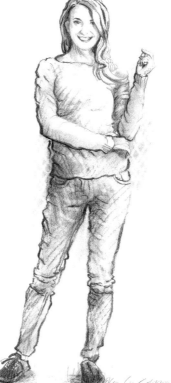

This pose is interesting because each arm and leg is positioned differently. Use several types of pencil strokes to add variety.

SITTING POSES

Most guidelines within the head are measured in thirds—from the chin to the nose, the nose to the eyebrow, and the eyebrow to the hairline. The center of the eyes falls about halfway between the top of the head and the bottom of the chin. Note how vertical plumb lines drop from the sides of the head and align with the hands. Use a light horizontal guideline to even the knee heights.

ON THE FLOOR

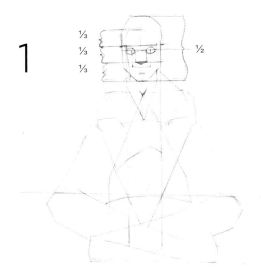

1

2

Start by rendering the head. Once its proportions are set, use it as a standard of measurement so the rest of the body will look natural and proportionate.

Compare this stage with step one to see just how important the lay-in was. A triangle from the shirt's base to the pit of the neck is still visible, as is a triangle from the shoulders to the inner wrists.

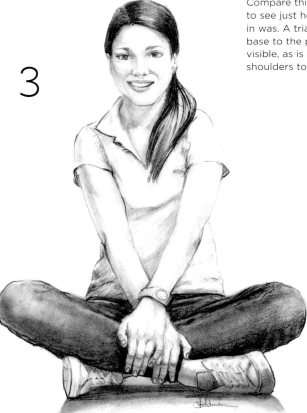

3

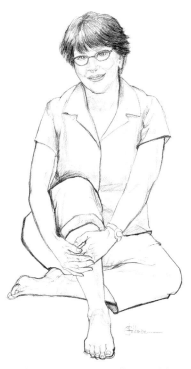

When constructing a figure with lines, vary the sizes and values of the lines for visual interest.

ON A BENCH

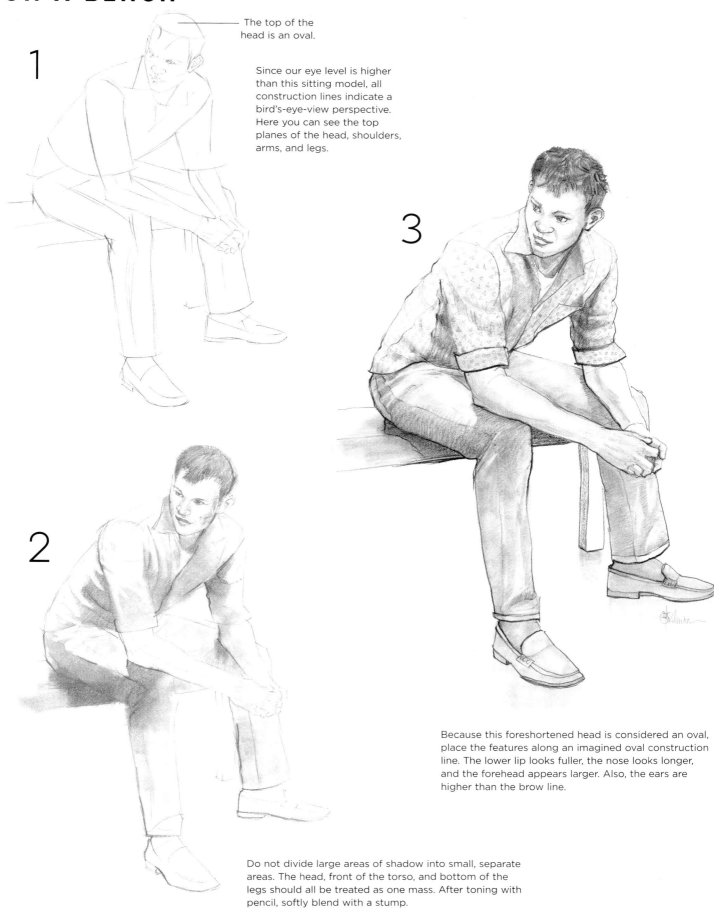

The top of the head is an oval.

1

Since our eye level is higher than this sitting model, all construction lines indicate a bird's-eye-view perspective. Here you can see the top planes of the head, shoulders, arms, and legs.

3

2

Because this foreshortened head is considered an oval, place the features along an imagined oval construction line. The lower lip looks fuller, the nose looks longer, and the forehead appears larger. Also, the ears are higher than the brow line.

Do not divide large areas of shadow into small, separate areas. The head, front of the torso, and bottom of the legs should all be treated as one mass. After toning with pencil, softly blend with a stump.

ON A STOOL

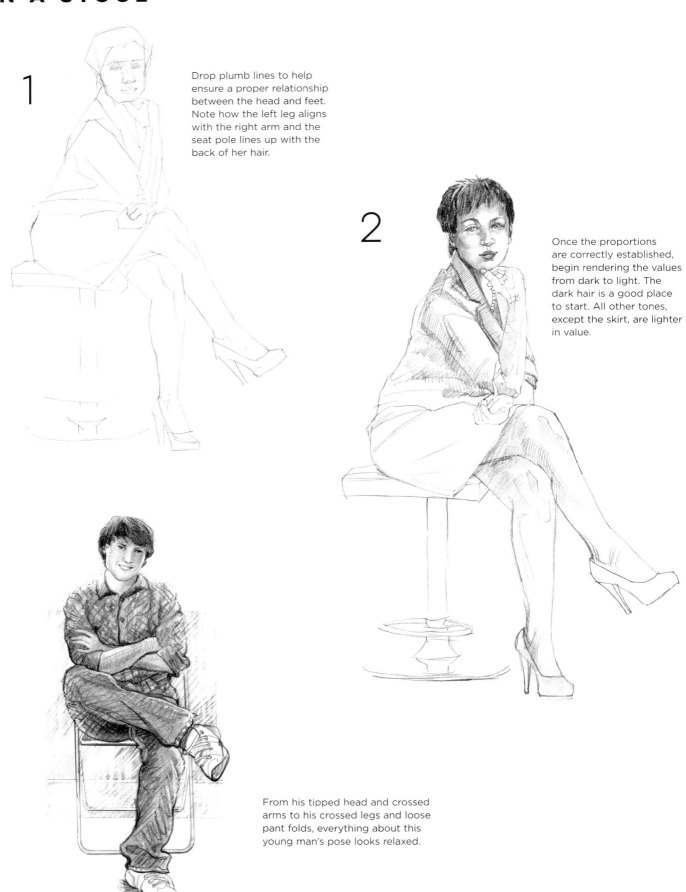

1

Drop plumb lines to help ensure a proper relationship between the head and feet. Note how the left leg aligns with the right arm and the seat pole lines up with the back of her hair.

2

Once the proportions are correctly established, begin rendering the values from dark to light. The dark hair is a good place to start. All other tones, except the skirt, are lighter in value.

From his tipped head and crossed arms to his crossed legs and loose pant folds, everything about this young man's pose looks relaxed.

3

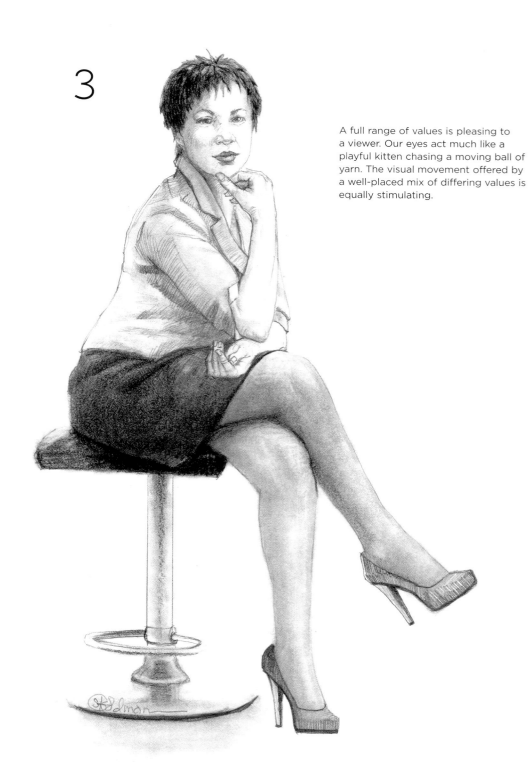

A full range of values is pleasing to a viewer. Our eyes act much like a playful kitten chasing a moving ball of yarn. The visual movement offered by a well-placed mix of differing values is equally stimulating.

HAND ON FLOOR

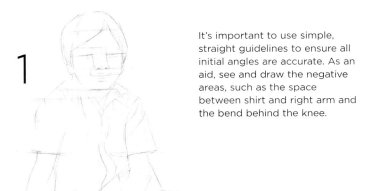

1

It's important to use simple, straight guidelines to ensure all initial angles are accurate. As an aid, see and draw the negative areas, such as the space between shirt and right arm and the bend behind the knee.

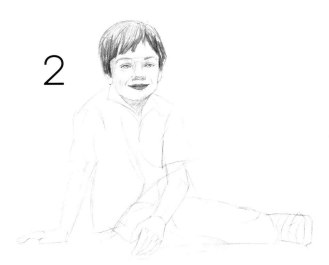

2

Next begin to darken the hair, eyes, lips, bottom of the nose, side of the head, and the neck. Keep the tones flat and two-dimensional, as you are still just trying to create accurate relationships between features.

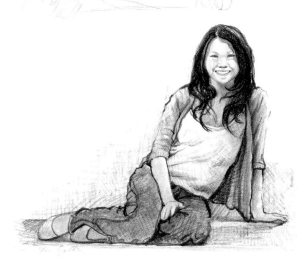

All dynamic poses are both active and passive. Here the right side of the torso is actively compressed while the left side is passively stretched.

3

The light source comes from the front, so all the forms are rendered subtly along their sides. To visualize how to render a central-lit figure, pretend you're wearing a miner's cap with a headlamp.

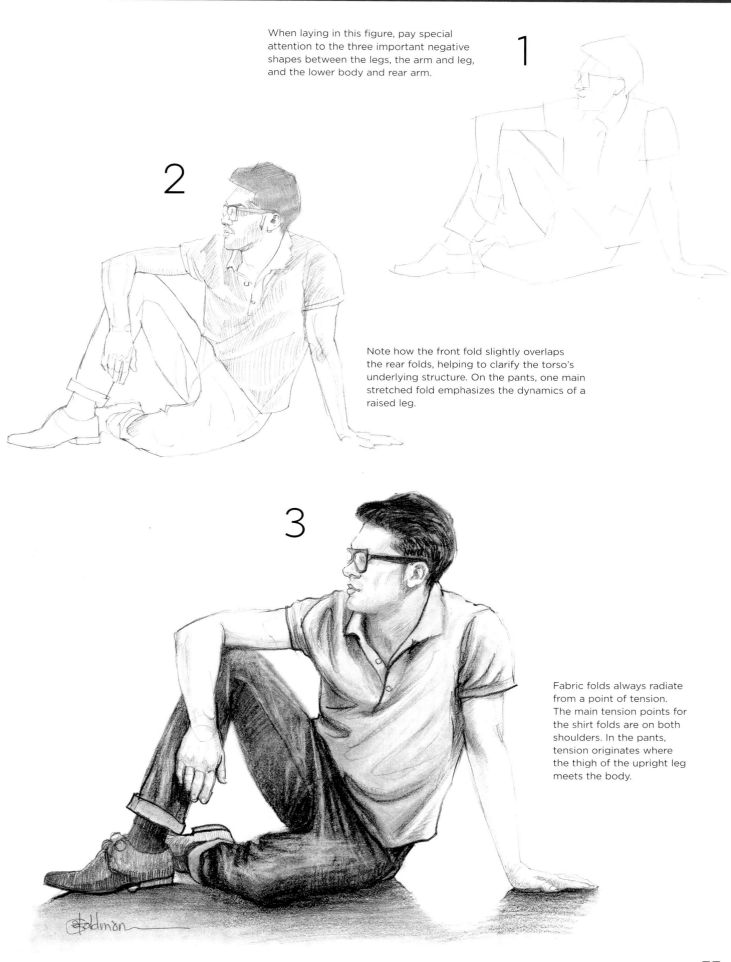

When laying in this figure, pay special attention to the three important negative shapes between the legs, the arm and leg, and the lower body and rear arm.

1

2

Note how the front fold slightly overlaps the rear folds, helping to clarify the torso's underlying structure. On the pants, one main stretched fold emphasizes the dynamics of a raised leg.

3

Fabric folds always radiate from a point of tension. The main tension points for the shirt folds are on both shoulders. In the pants, tension originates where the thigh of the upright leg meets the body.

CHILDREN SITTING

This pose gains most of its appeal through pleasing shapes and good values—plus the cute face! Adding small details, such as the flower in her hair, on her pants, and on her shoes, makes the composition more visually pleasing, as well.

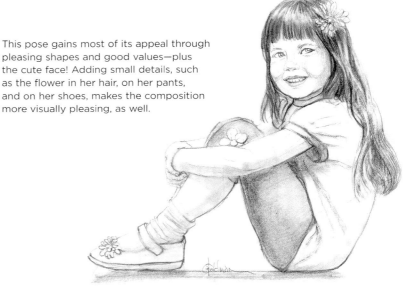

This particular pose, with the head slightly tilted and the arms gently stretching forward to hold the knee, is not only well composed, but demonstrates the use of key shapes, including cylinders and ovals, in blocking in the initial form.

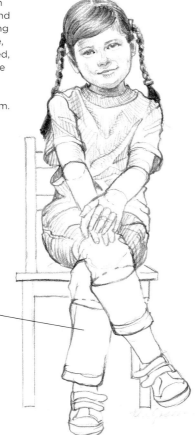

To correctly analyze the foreshortened volumes of arms, fingers, and legs during lay-in, note the importance of the cylinders. It's easier to draw anatomical contours once these simple forms are established.

Weight placed on this young girl's arm creates an interesting dynamic between her curved body and counter-tipped head.

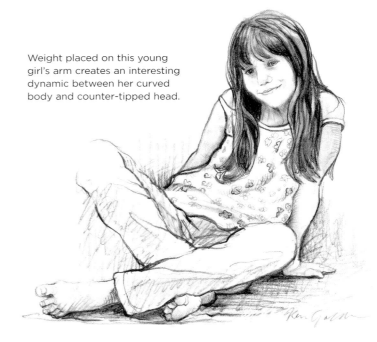

Rendering Hair

Light & Wavy
Use graphite powder (created by rubbing a pencil tip over sandpaper) and a stump to create a base of light, subtle tone. Add long, flowing lines, following the soft waves of the hair. Keep the strands in the foreground very light to emphasize the color of the hair.

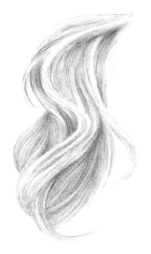

Dark & Wavy
Draw the main, curving hair forms; layer in some graphite powder; and draw wavy lines with the point of a 2B pencil. Use a 4B for the darkest darks and lift out the lighter, highlighted strands with a kneaded eraser.

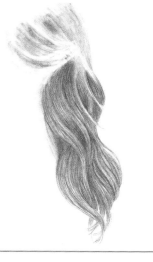

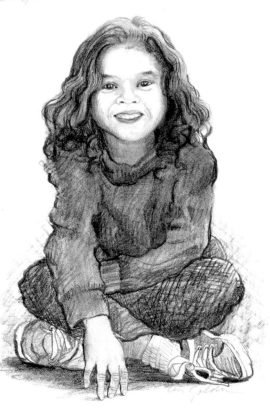

Contrast between the strokes and the blended areas, as well as the negative shape below the knees, adds interest to this pose. Notice the detail of the hair falling gently behind her leg farthest away from the viewer, suggesting a natural, unrehearsed moment.

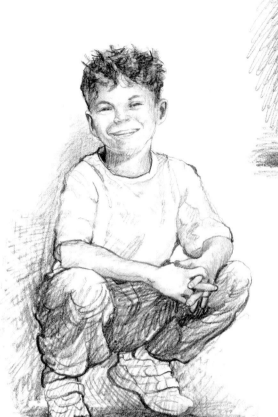

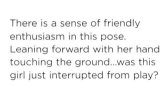

When one is smiling big or laughing, the cheek muscles pull upward and compress the bottoms of the eyes upward, hence the expression "laughing eyes."

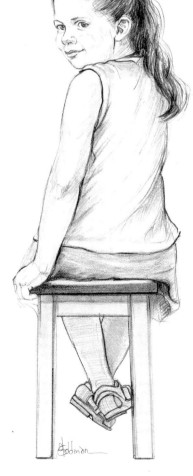

There is a sense of friendly enthusiasm in this pose. Leaning forward with her hand touching the ground...was this girl just interrupted from play?

When depicting a three-quarter view, cover the far eye's inner corner with the nose bridge and construct the lips over a rounded shape.

HANDS ON FACES

Resting the face on one or both hands has long been a pose used to express a range of emotions, from indifference to sadness to mischief to cheer.

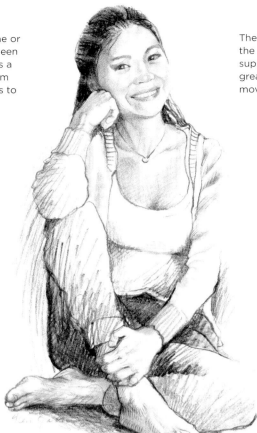

The placement of a hand on the ankle in addition to a hand supporting the face provides a great attention-holding circular movement from arm to arm.

This model's feet started with block-like forms. It is easier to render the extremities as blocky shapes and then refine them while adding the details.

This pose—and the mischievous smile on this young girl's face— conveys interest.

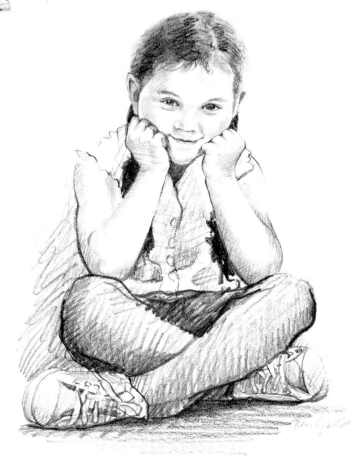

When a mouth is slightly open, indicate its round shape by adding shading around the sides.

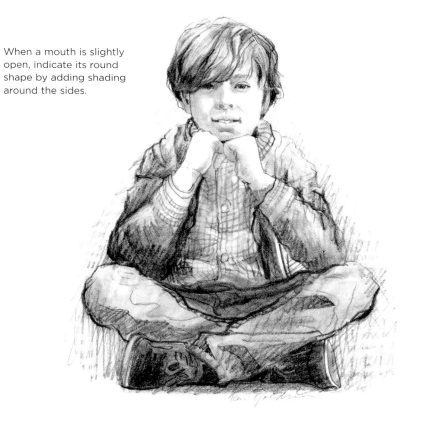

Sometimes a design element such as this circle brings out just the right focus on the face by highlighting its surrounding negative areas.

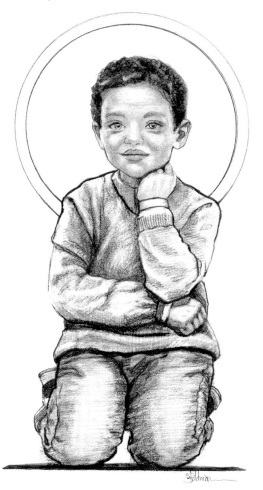

There is something charming and playfully coy about this pose. Perhaps it's the gesture of her head in hands or the endearing turned-in position of her feet?

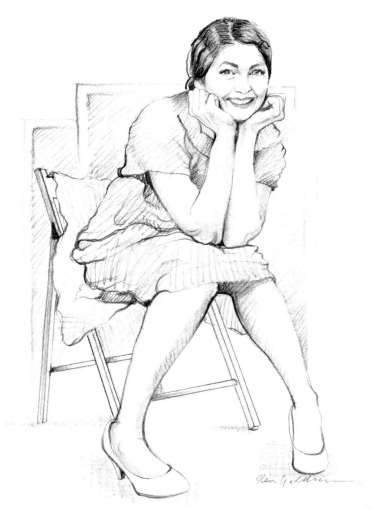

RECLINING POSES

Reclining poses usually invoke *foreshortening*: a technique for rendering people or objects that aren't parallel to the picture plane. This involves shortening the lines of the sides of the object closest to the viewer. For example, a standing figure with the arms positioned straight down by the side of the body is perfectly vertical and in proportion. However, once the arm is raised out toward the viewer, it becomes angled and is no longer parallel to the picture plane; the hand looks bigger while the arm looks shorter. Capturing that image in proportion is called "foreshortening."

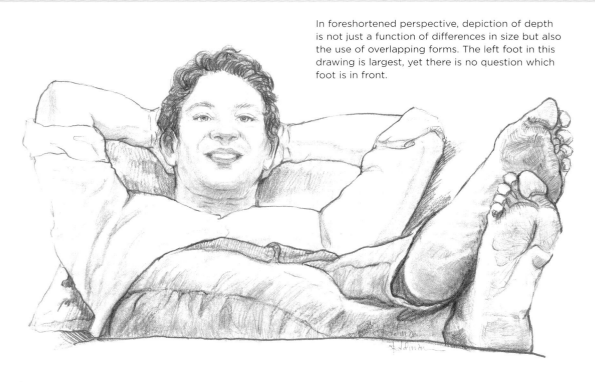

In foreshortened perspective, depiction of depth is not just a function of differences in size but also the use of overlapping forms. The left foot in this drawing is largest, yet there is no question which foot is in front.

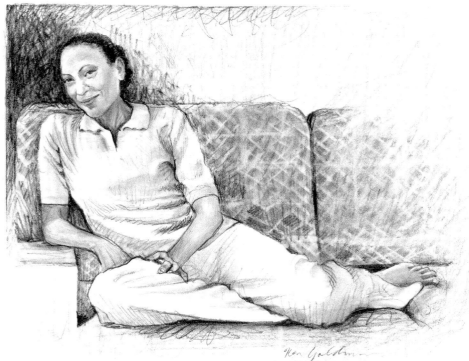

This drawing was based off of a flat, low-contrast photo but was made more interesting with varying edges: a hard edge against the face and softer edges for the hair and sofa.

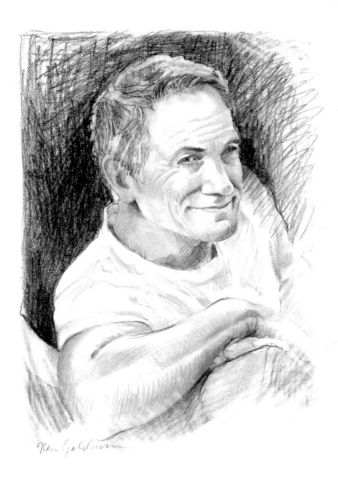

The interest in this pose comes from the man's relaxed facial expression, which mirrors the relaxed position of his arms and upper torso. Facial lines are best indicated with top lighting using small, semi-cylindrical shapes and subtle shading.

To maintain emphasis on the pose, this drawing uses strong, dark lines on the figure that contrast the light, scribbled lines in the background.

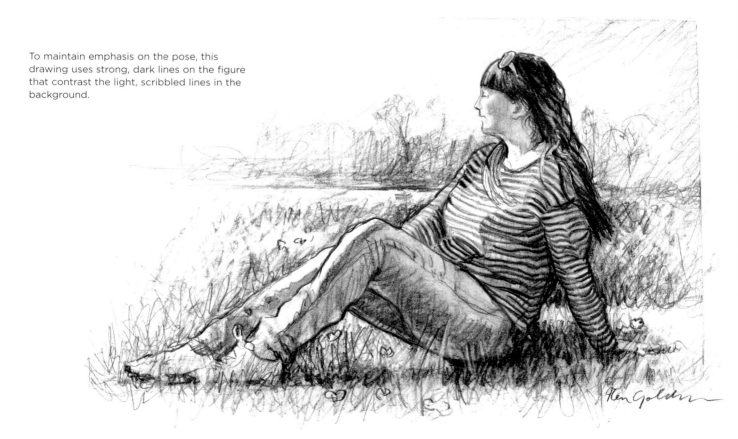

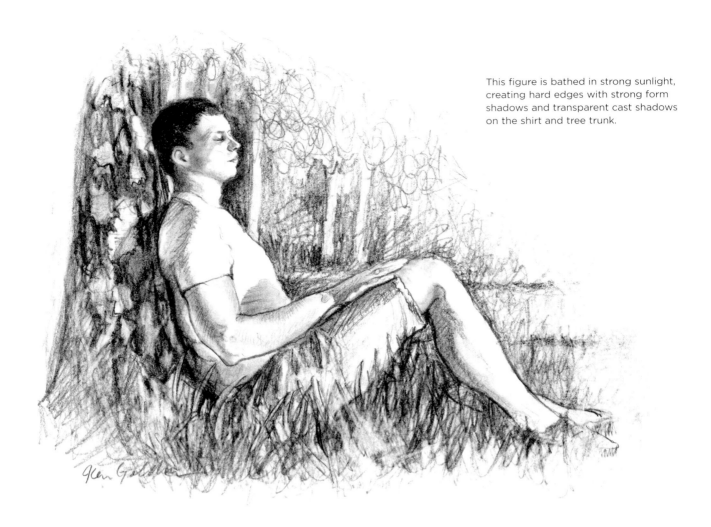

This figure is bathed in strong sunlight, creating hard edges with strong form shadows and transparent cast shadows on the shirt and tree trunk.

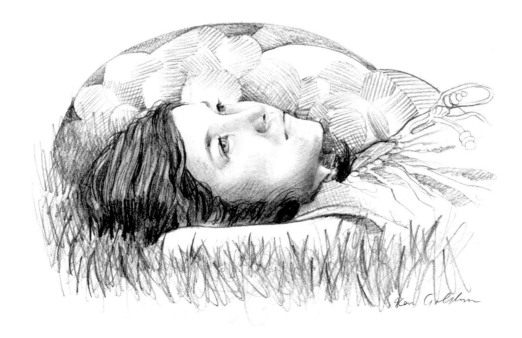

The daydreaming expression of this figure is complemented by the abstract circular shapes in the background, textured with hatching for interest.

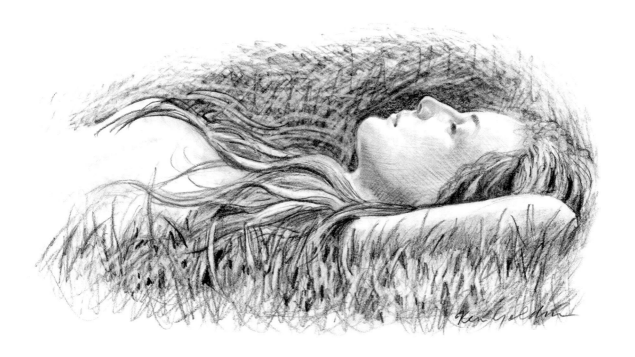

Although the face is shaded delicately with a blending stump and pencil strokes, most everything else in this drawing is rendered texturally with a vinyl eraser.

Lovely negative shapes surround this entire figure, and a pleasing diagonal points from the leg to the head. Use textured values to create visual stimulation.

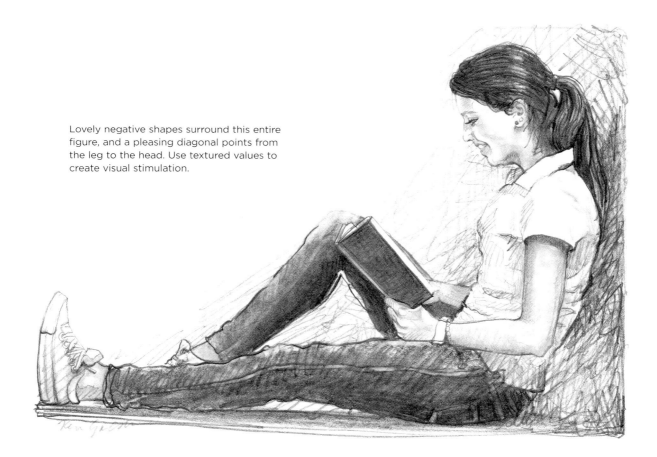

ON STOMACH

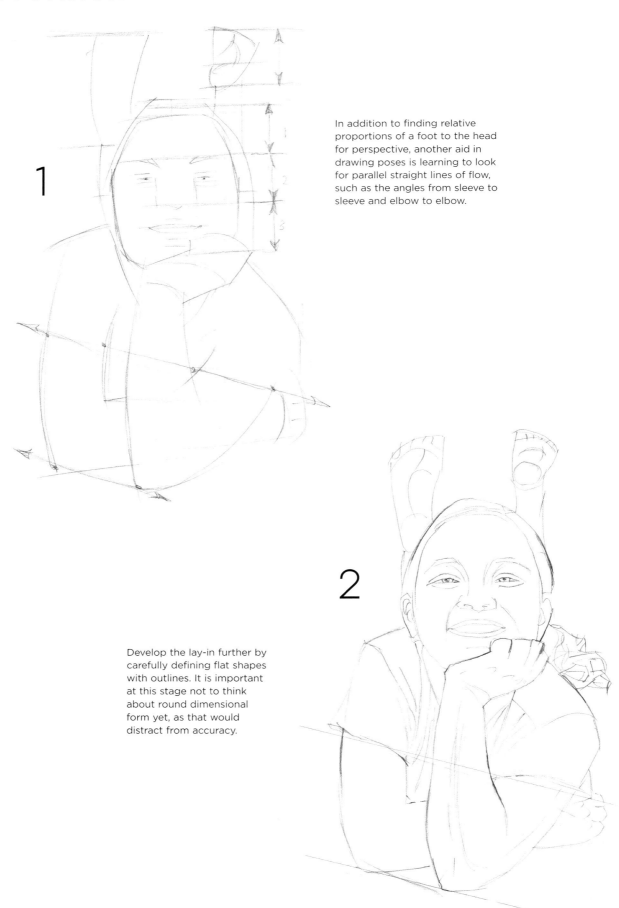

1

In addition to finding relative proportions of a foot to the head for perspective, another aid in drawing poses is learning to look for parallel straight lines of flow, such as the angles from sleeve to sleeve and elbow to elbow.

2

Develop the lay-in further by carefully defining flat shapes with outlines. It is important at this stage not to think about round dimensional form yet, as that would distract from accuracy.

3

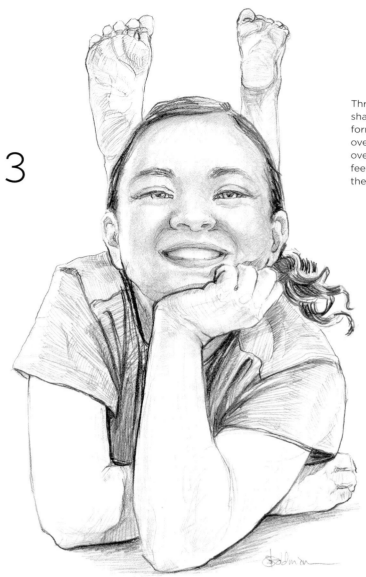

Through shading, the two-dimensional shapes become three-dimensional forms, with foreshortening evident by overlapping the arms, placing the head over the shoulders, and keeping the feet lighter and less fully rendered than the head.

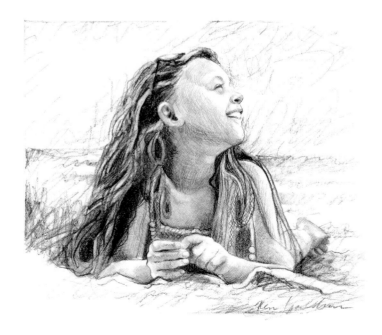

Because the head and hands are a main focal point in this drawing, the distant foreshortened foot is deliberately left vague. This is one benefit of incorporating background details—even loosely rendered—into your artwork, as it allows you to blend the figure into its setting without compromising the integrity of the drawing.

ON SIDE

A good way to approach this semi-reclining male figure is to first look for common denominator flow lines and simultaneously the negative spaces that surround him, as indicated here with grid lines. Both are important for accurate draftsmanship and good design.

After establishing a good gestural flow, you can concentrate on rendering the angles. First draw in the longest angles; then look for the smaller changes of directions, which are indicated here with an X.

Much of the rendering here is accomplished by drawing values into shapes with graphite, blending them with a stump and then adding "form-following" direction lines with a sharpened pencil and the tip of an eraser.

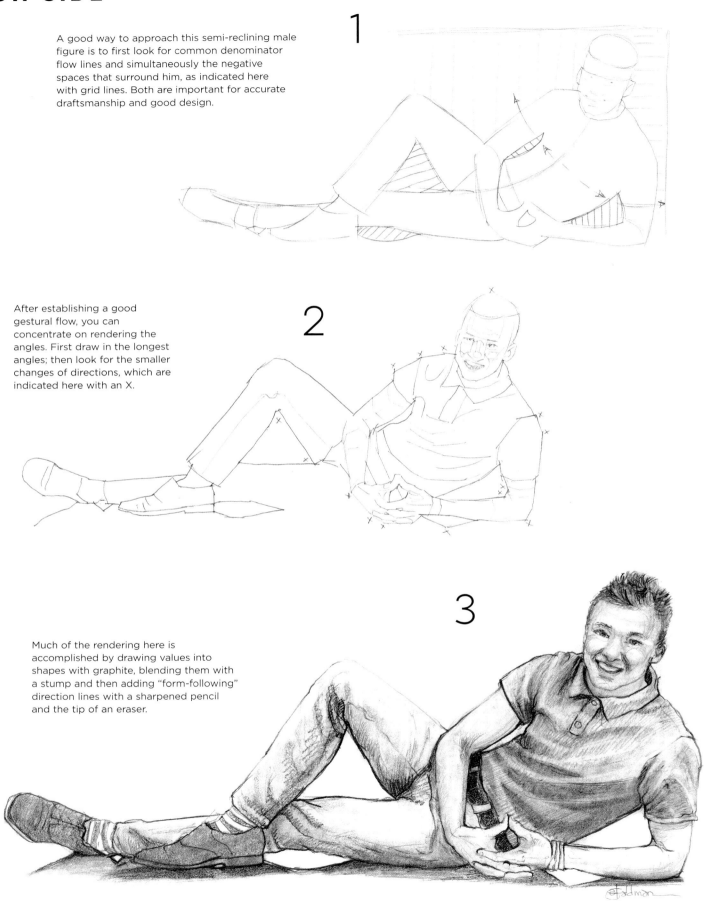

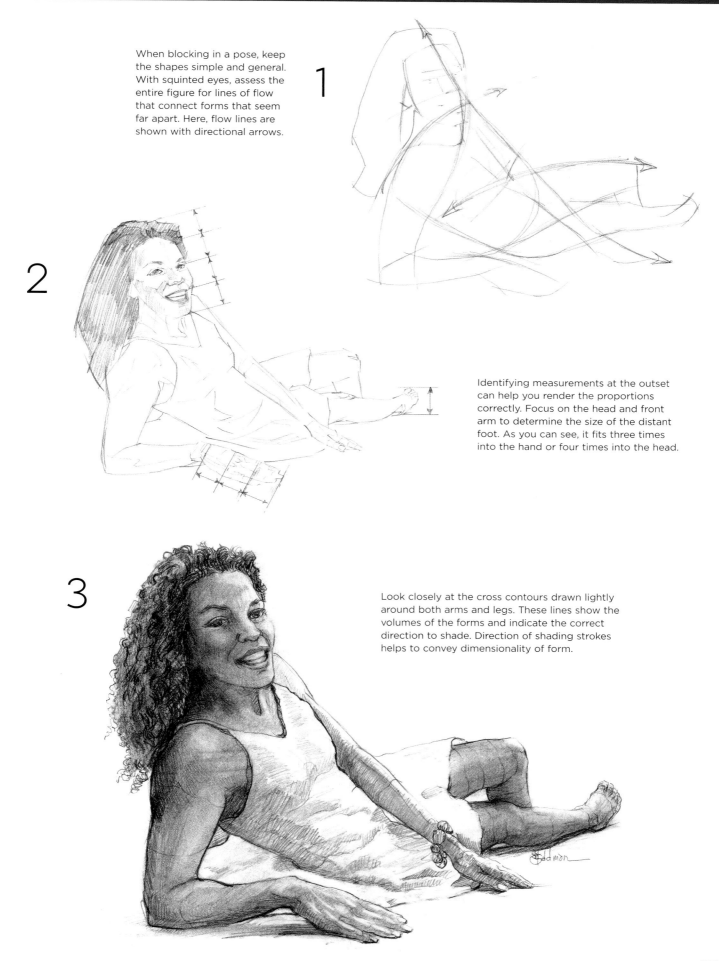

When blocking in a pose, keep the shapes simple and general. With squinted eyes, assess the entire figure for lines of flow that connect forms that seem far apart. Here, flow lines are shown with directional arrows.

1

2

Identifying measurements at the outset can help you render the proportions correctly. Focus on the head and front arm to determine the size of the distant foot. As you can see, it fits three times into the hand or four times into the head.

3

Look closely at the cross contours drawn lightly around both arms and legs. These lines show the volumes of the forms and indicate the correct direction to shade. Direction of shading strokes helps to convey dimensionality of form.

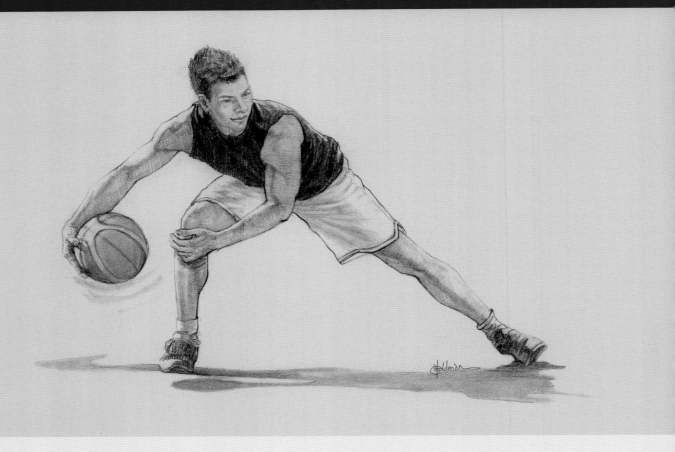

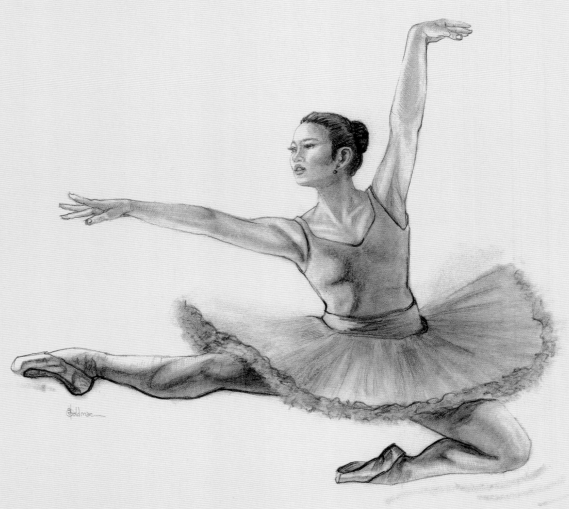

Chapter 3

DYNAMIC POSES

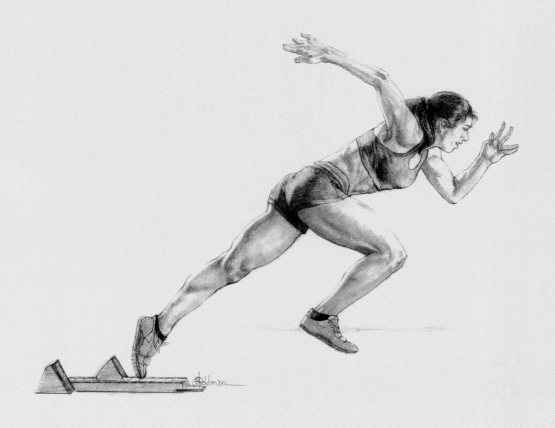

MOVEMENT & BALANCE

Drawings are made more realistic when figures are shown in action. Begin by using simple sketch lines to lay out the dominant action of the figure.

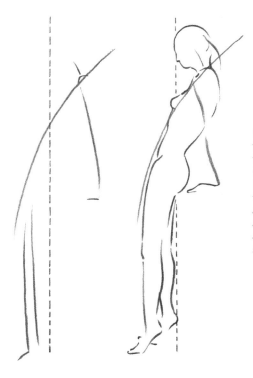

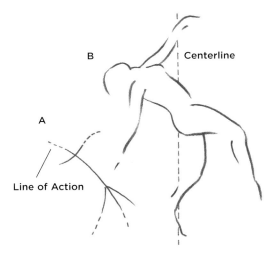

Use an imaginary centerline that seems to hold or balance the figure in its position. Otherwise, the figure may look as though it's going to fall over. The best way to achieve balance is to place approximately the same amount of weight on either side of this centerline.

Another tip is to draw a line that represents the spine of the figure in its action pose; then develop the pose from this *line of action* (a line that indicates the curve and movement of the body). Using both the centerline of balance and the line of action will help you establish convincing movement in your figure drawings.

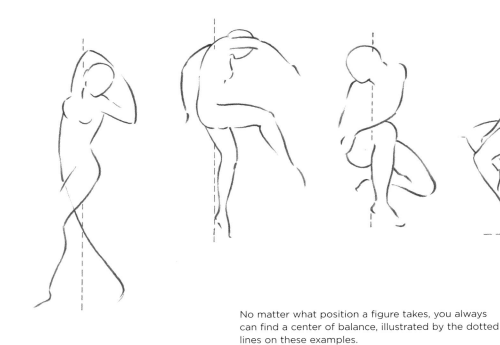

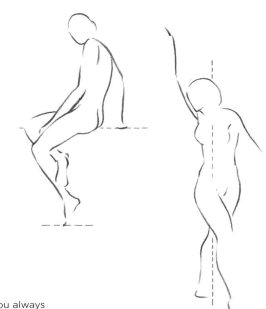

No matter what position a figure takes, you always can find a center of balance, illustrated by the dotted lines on these examples.

All the parts of the body combine to show movement of the figure. Our jointed skeleton and muscles allow us to bend and stretch into many different positions. To create drawings with realistic poses, it helps to study how a body looks and changes when stretched or flexed, as well as when sitting or standing. Begin by drawing the line of action or "gesture" first; then build the forms of the figure around it.

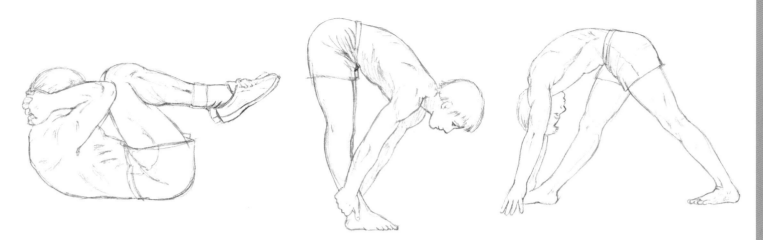

The spine is flexible and allows us to bend many ways while stretching and contracting our limbs. These three poses show how the shape of the body can change drastically while the proportions stay the same.

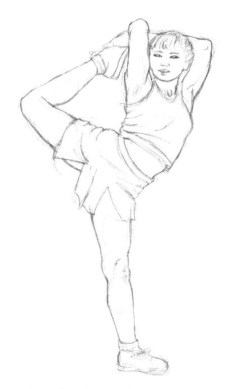

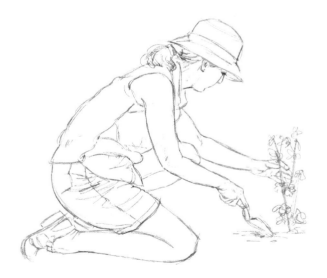

You can almost feel the muscles stretching on this cheerleader's body as she pulls up her right leg behind her head. Notice how the bending figure creates wrinkles and tightly stretched areas in the clothing. Be sure to draw these creases and smooth areas to make your drawing believable.

This woman kneeling in her garden is bending into an S shape. All wrinkles or folds in the fabric are on the inward side of the body's bend; the back side is fairly smooth. The curve of her turned head has only a slight influence on the line of action.

BALLERINA

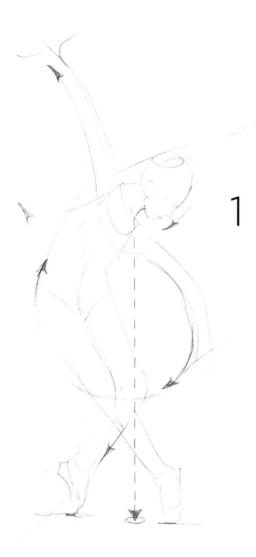

1

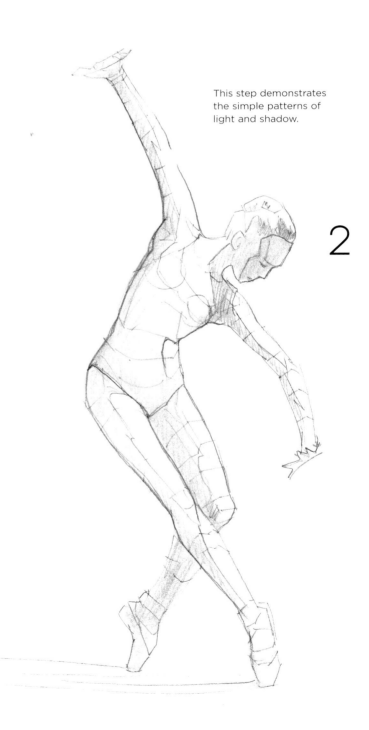

2

This step demonstrates the simple patterns of light and shadow.

As indicated by the directional arrows, graceful flow lines help establish this elegant gesture. Note how the center of balance falls directly from the pit of the neck between the ballerina's feet, anchoring her to the floor.

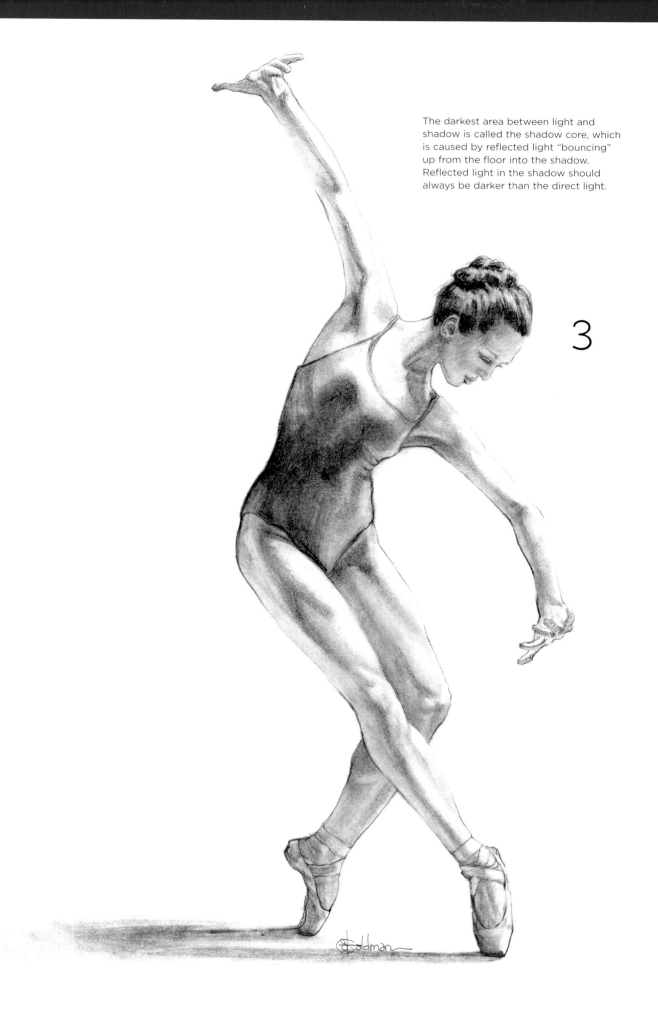

The darkest area between light and shadow is called the shadow core, which is caused by reflected light "bouncing" up from the floor into the shadow. Reflected light in the shadow should always be darker than the direct light.

3

BALLERINA IN TUTU

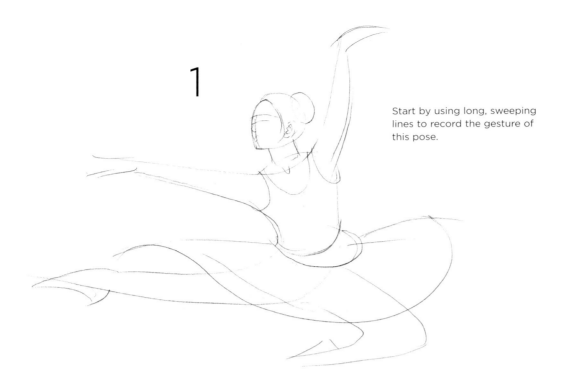

1

Start by using long, sweeping lines to record the gesture of this pose.

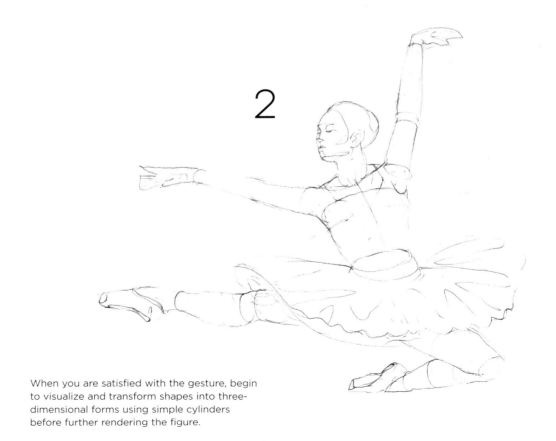

2

When you are satisfied with the gesture, begin to visualize and transform shapes into three-dimensional forms using simple cylinders before further rendering the figure.

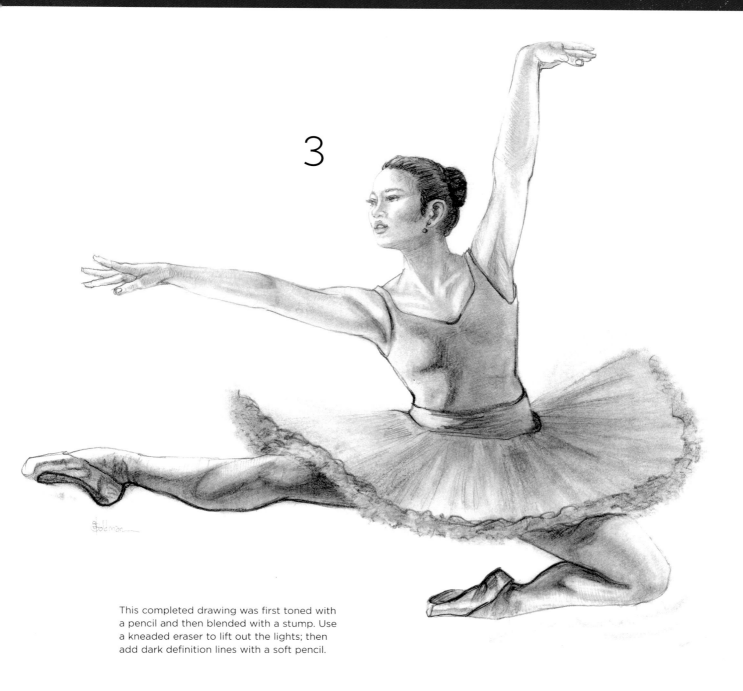

3

This completed drawing was first toned with a pencil and then blended with a stump. Use a kneaded eraser to lift out the lights; then add dark definition lines with a soft pencil.

Using a Kneaded Eraser

The kneaded eraser (usually gray) is a favorite for graphite artists. It is pliable like clay, allowing you to form it into any shape. Knead and work the eraser until it softens; then dab or roll it over areas to slowly and deliberately lighten the tone. This eraser does not leave behind crumbs. To "clean" it, simply knead it. The eraser will eventually take in too much graphite to cleanly lift tone off the paper; at this point, you will need to replace it.

Use a kneaded eraser to dab or roll for soft, subtle lightening.

SPRINTER

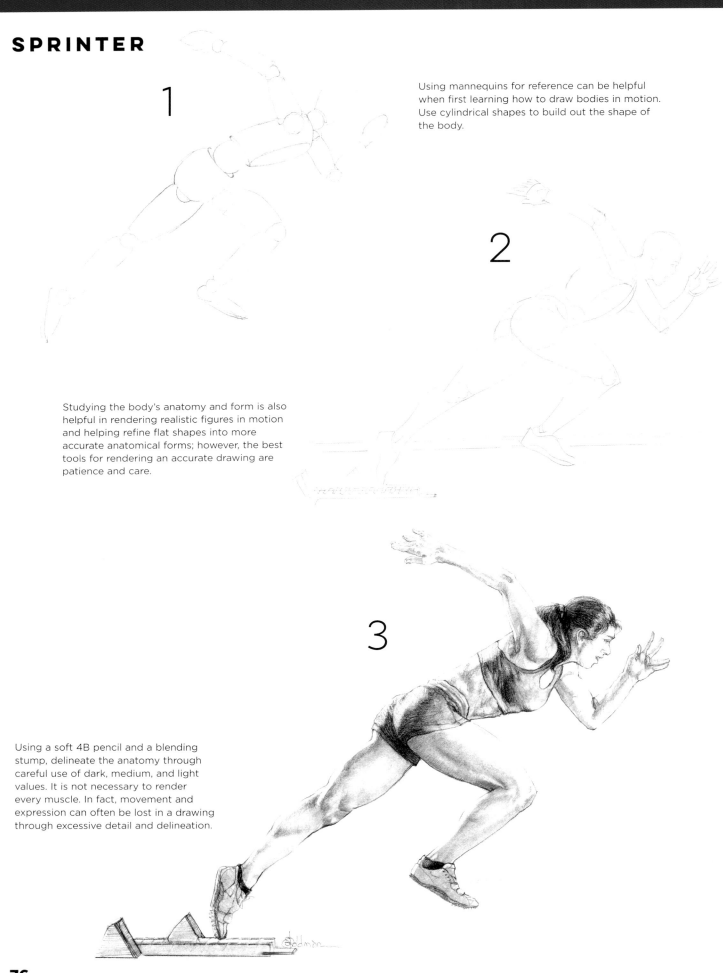

1

Using mannequins for reference can be helpful when first learning how to draw bodies in motion. Use cylindrical shapes to build out the shape of the body.

2

Studying the body's anatomy and form is also helpful in rendering realistic figures in motion and helping refine flat shapes into more accurate anatomical forms; however, the best tools for rendering an accurate drawing are patience and care.

3

Using a soft 4B pencil and a blending stump, delineate the anatomy through careful use of dark, medium, and light values. It is not necessary to render every muscle. In fact, movement and expression can often be lost in a drawing through excessive detail and delineation.

RUNNER

Using cylindrical shapes once again helps capture the anatomy, mass, and volume of this figure in motion. Notice how clearly the front and side planes of the torso are differentiated from one another.

1

Lay in the value differences between the fronts and sides of the torso, legs, arms, neck, and face using loose strokes. After identifying the light source, block in areas of shadows using light, quick hatchmarks.

2

To finish the drawing, blend the pencil strokes and finish working out the anatomy of the body in motion. Work to convey the volume of the body by further indicating the primary light source, shadow core, and reflected light on the front leg, as well as a cast shadow.

3

SOCCER PLAYER

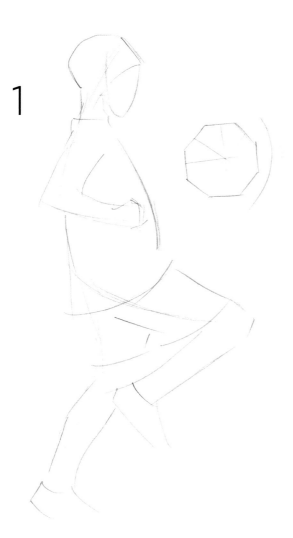

1

The gestural movements of a soccer player, or footballer, are dynamic. What matters most is maintaining the relationship between the upward-moving leg and the moving ball. Keep the lines simple so that the minor details won't hinder the overall rhythm.

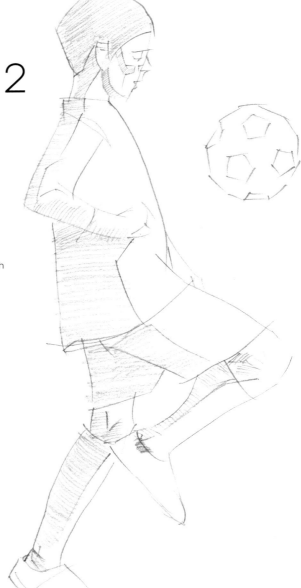

2

To maintain the rhythm of the pose, simply distinguish the front and back planes in preparation for adding the final details.

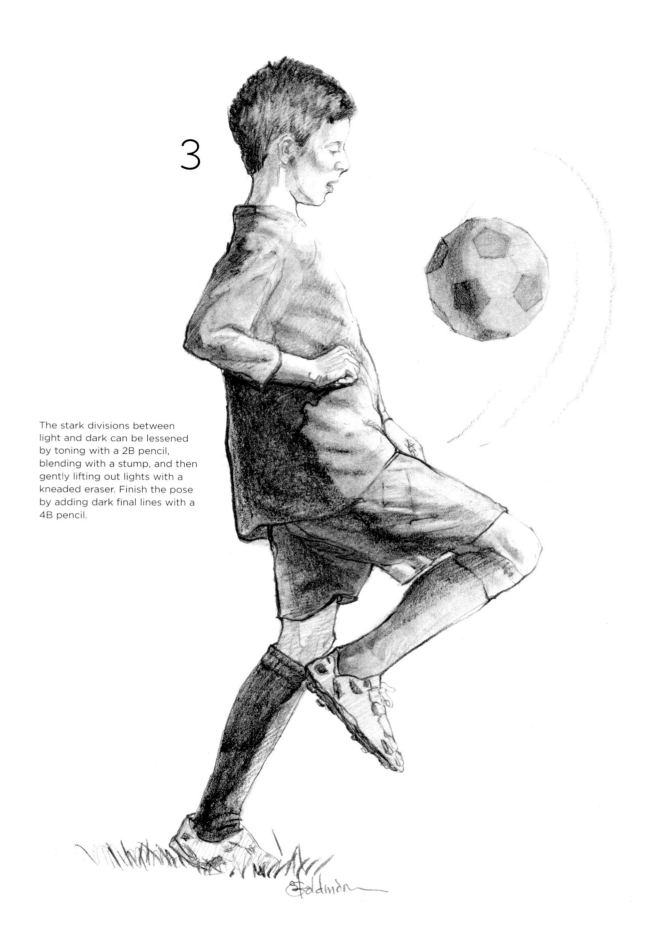

3

The stark divisions between
light and dark can be lessened
by toning with a 2B pencil,
blending with a stump, and then
gently lifting out lights with a
kneaded eraser. Finish the pose
by adding dark final lines with a
4B pencil.

BASKETBALL PLAYER

In addition to the dynamism maintained from the initial gesture of this pose, the motion lines surrounding the basketball and the extreme contrast between the light shorts and dark jersey add visual excitement.

3

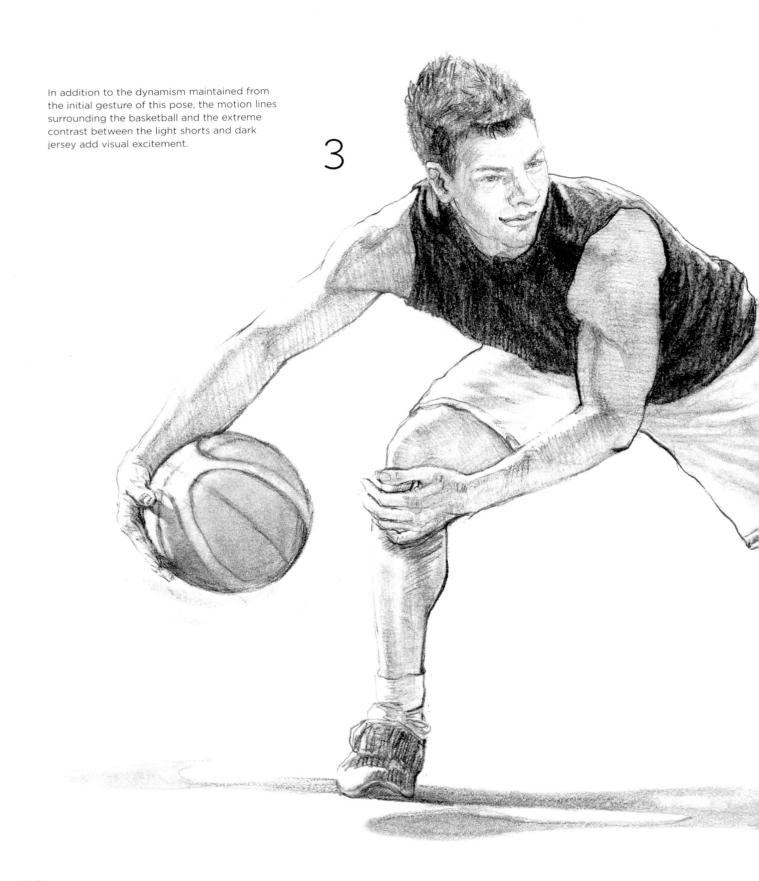

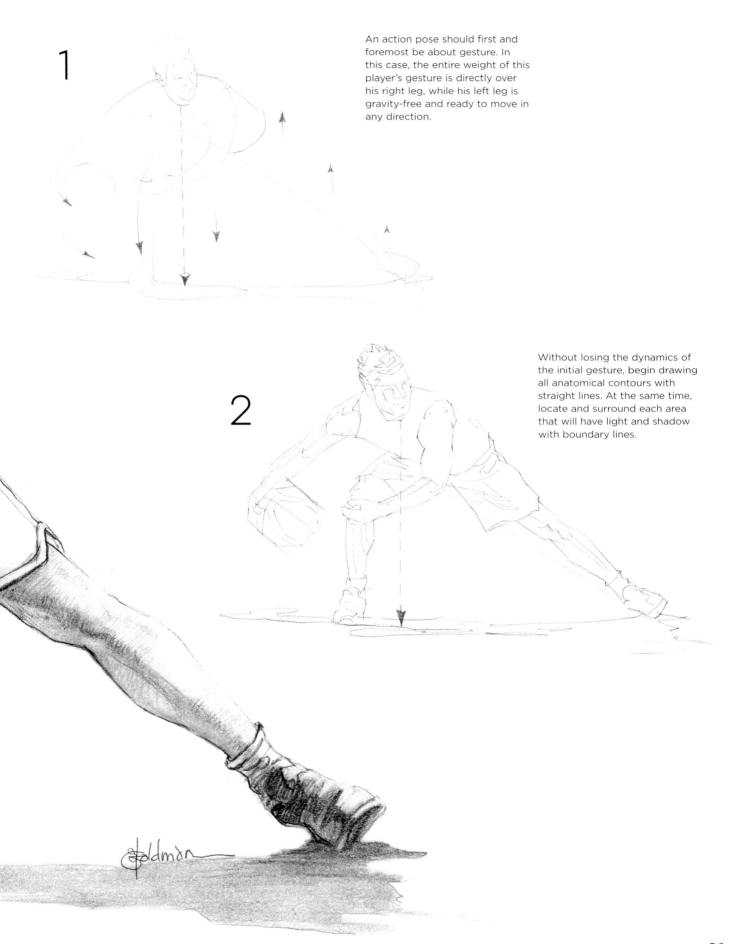

1

An action pose should first and foremost be about gesture. In this case, the entire weight of this player's gesture is directly over his right leg, while his left leg is gravity-free and ready to move in any direction.

2

Without losing the dynamics of the initial gesture, begin drawing all anatomical contours with straight lines. At the same time, locate and surround each area that will have light and shadow with boundary lines.

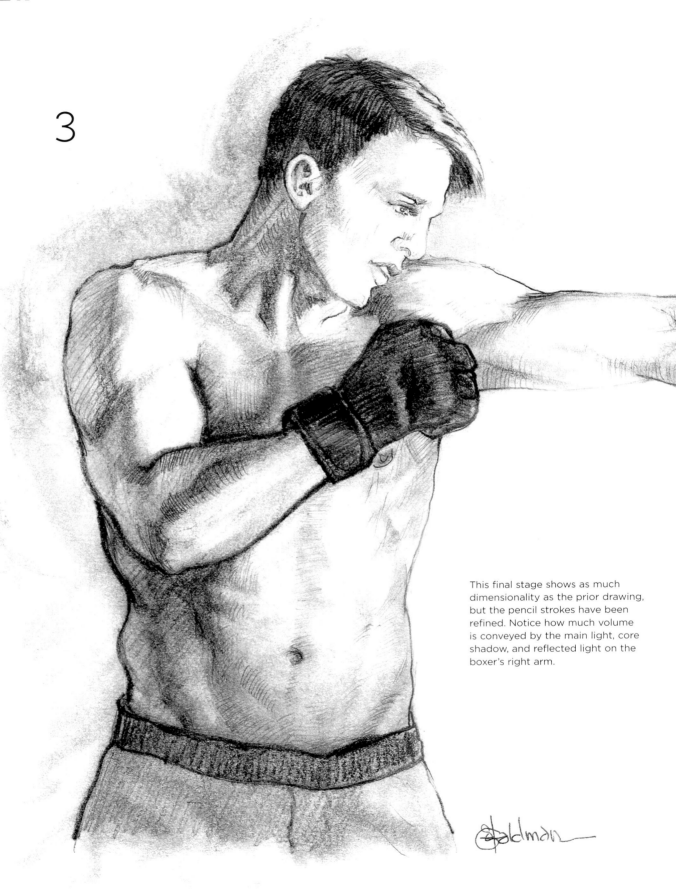

3

This final stage shows as much dimensionality as the prior drawing, but the pencil strokes have been refined. Notice how much volume is conveyed by the main light, core shadow, and reflected light on the boxer's right arm.

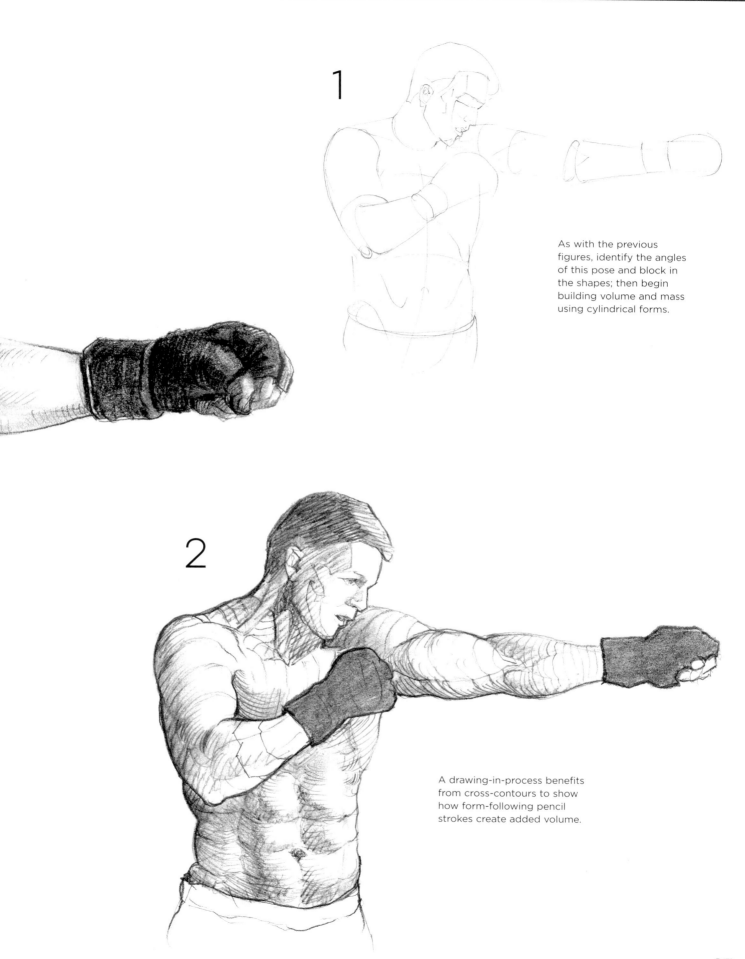

1

As with the previous figures, identify the angles of this pose and block in the shapes; then begin building volume and mass using cylindrical forms.

2

A drawing-in-process benefits from cross-contours to show how form-following pencil strokes create added volume.

SWIMMER

1

To find symmetry in this pose, establish the center of the figure; then use a light guideline to ensure the arms are drawn level.

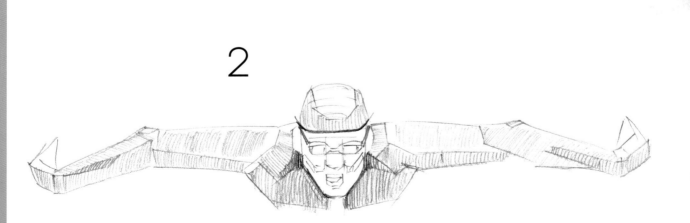

2

Even though this pose looks simple, the subtleties of its anatomy are not. As usual, the best approach to any complex anatomical puzzle is to begin simply by defining tops, sides, and bottoms of all muscle forms.

3 With the addition of the water, this pose now has the necessary context to show us just what this swimmer is doing. The dark torso and foreground reflection have become useful tools in defining the frontal splash area.

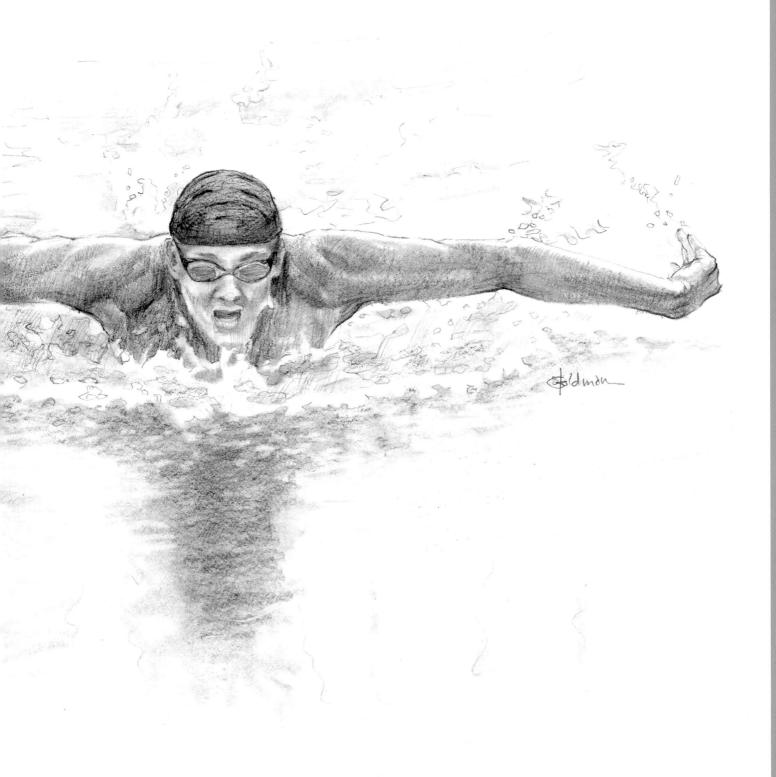

CHILDREN IN ACTION

If you ever spend time watching children at play, you'll notice that they are constantly interacting with their environment. From splashing in water, kicking, and throwing to picking flowers, these busy little humans are lively and somewhat unpredictable. Aim to capture this "in the moment" appeal in your drawings. In this step-by-step exercise, you can see that a child's movements need not always be of the rough-and-tumble variety. This pose shows the gentle motion of a young girl blowing a dandelion.

CHILD WITH FLOWER

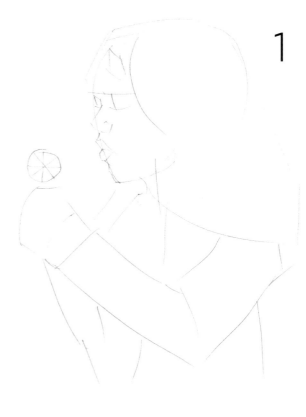

1 Full profiles are much easier to draw than "almost" profiles. To correctly capture eye and nose proportions, begin with the far eye first and carefully and proportionally work your way outward, blocking in the basic shapes to start.

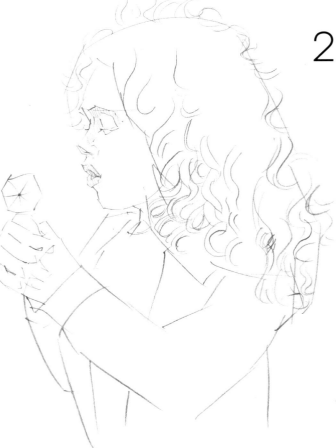

2

Lightly draw in the details, keeping outlines soft and simple.

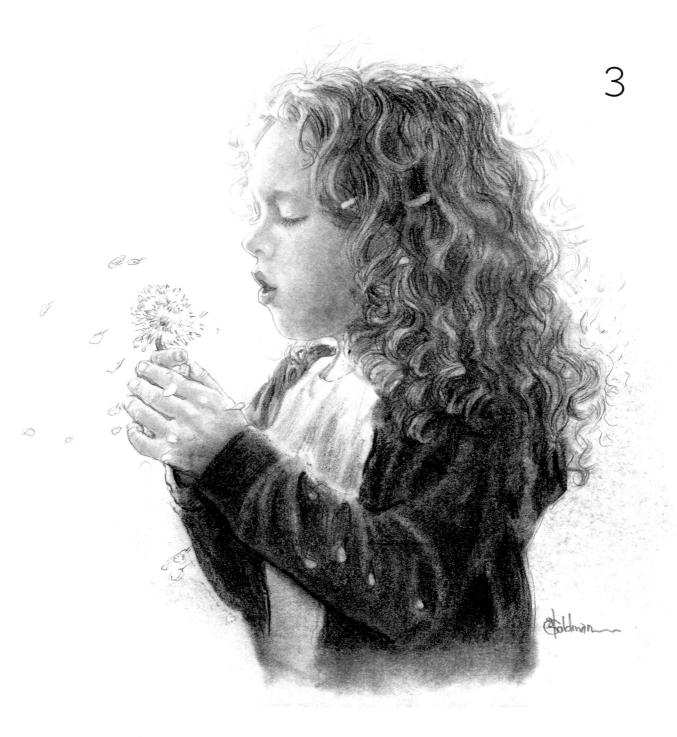

3

Begin refining the details, including the face, hair, and hands. Notice how the dark hair and sweater have soft edges, while the face and hands have more defined edges.

CHILD RUNNING

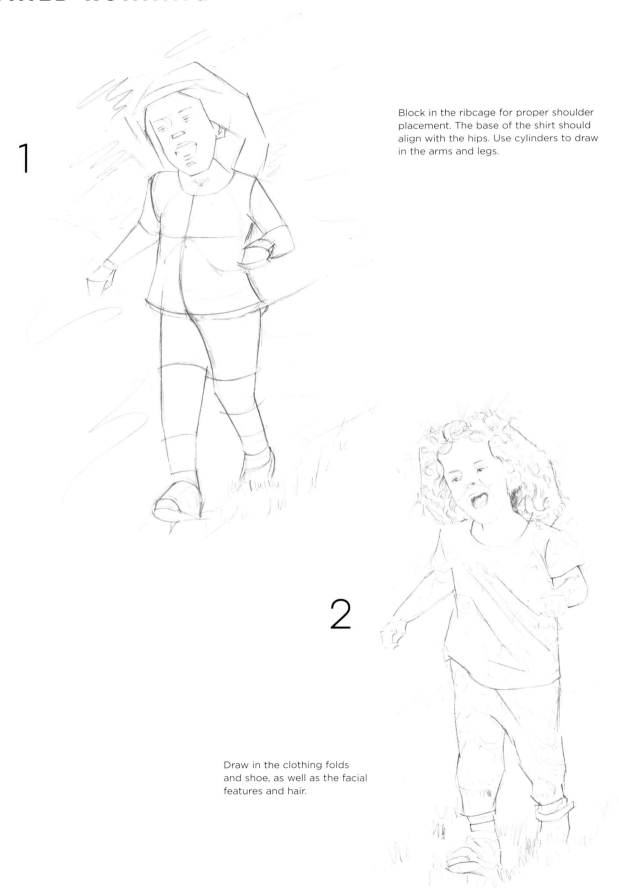

1

Block in the ribcage for proper shoulder placement. The base of the shirt should align with the hips. Use cylinders to draw in the arms and legs.

2

Draw in the clothing folds and shoe, as well as the facial features and hair.

3

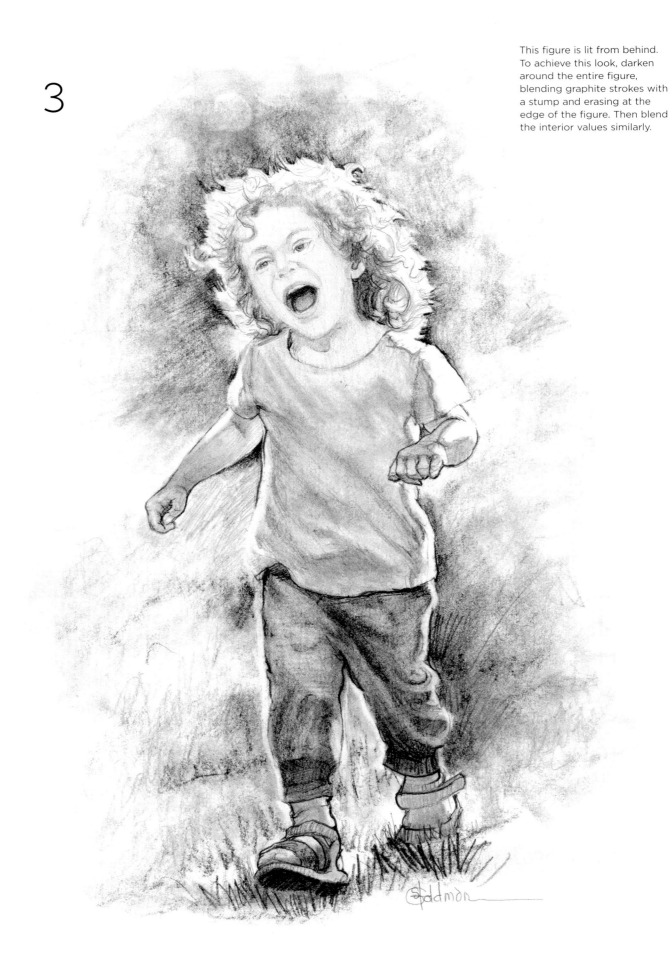

This figure is lit from behind. To achieve this look, darken around the entire figure, blending graphite strokes with a stump and erasing at the edge of the figure. Then blend the interior values similarly.

KIDS AT PLAY

The same principles of drawing adults in action can be applied to drawing children. But remember, children's arms and legs usually are pudgier than those of an adult, and the proportions of children's bodies are different.

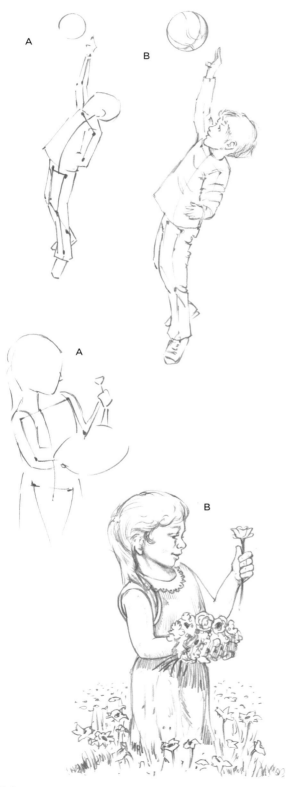

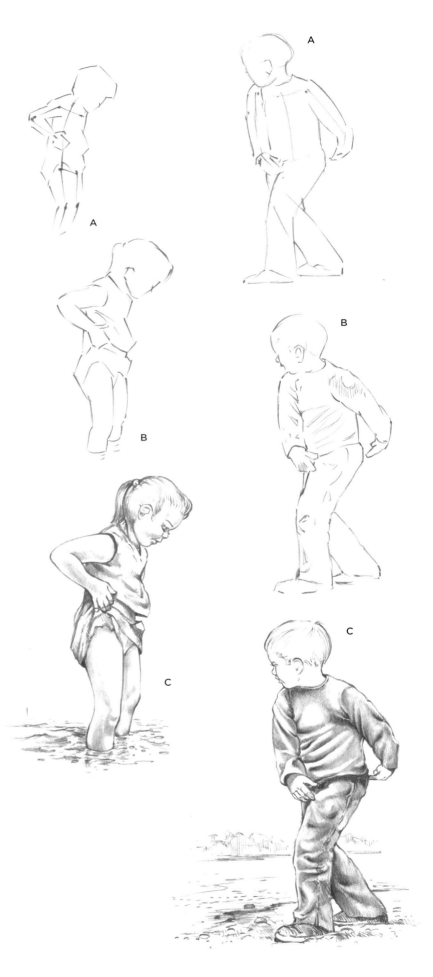

Assessing Movement in Children

To capture a child's actions, train your eye to assess the essential elements of the movement, and then quickly draw what you see. You can rapidly record details through a gesture drawing. As you can see below, a quick sketch is all you need to capture the main gesture—you can always add details later.

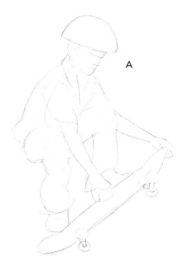

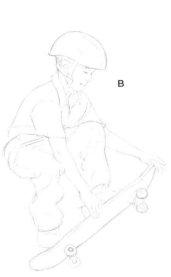

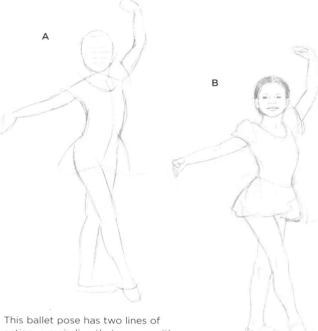

Record this action as you would any other: Draw the line of action down the spine, sharply curving through the left thigh. Then add the arms and the right leg for balance. Keep the head in line with the spine.

Minimal shading and detail are the best ways to keep the movement from looking stiff.

This ballet pose has two lines of action: a main line that curves with the torso and runs down the left leg, and a secondary line that starts at the left hand and flows across the chest through the right arm. Most of her weight is on the left leg, with the right extended for balance.

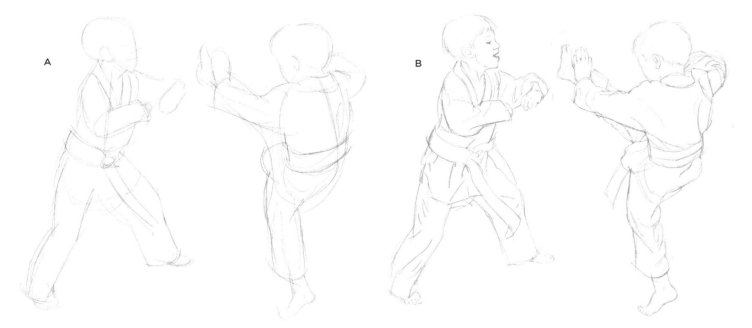

For the boy on the left, the line of action moves down his spine and through his left leg, where his weight is balanced. The boy on the right is kicking with his right leg—note the way the kick causes his body to bend forward in order to balance, curving the line of action at the base of his spine.

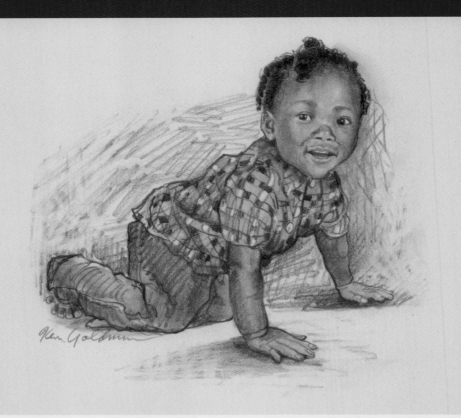

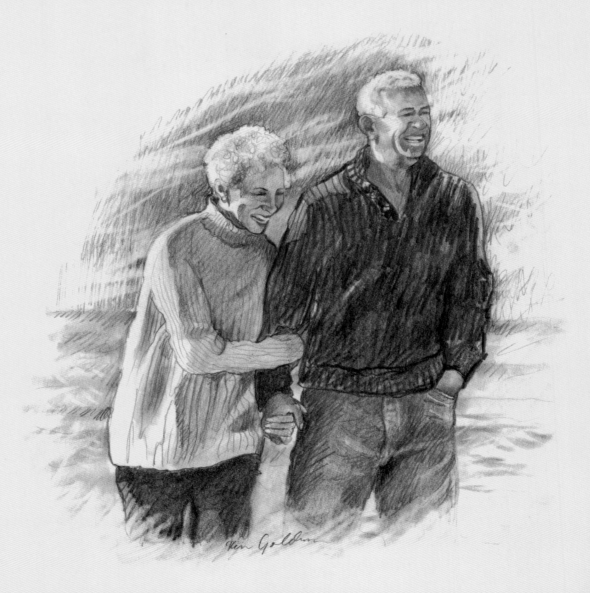

Chapter 4

EXPRESSIVE PORTRAITS

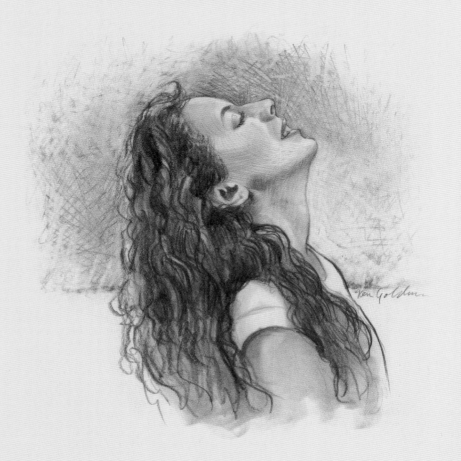

DRAWING ALL AGES

As you have learned so far, drawing a figure in any pose—whether it is static or in motion—is just a small part of mastering the complexities of figure drawing. There are many other considerations that go into rendering realistic poses, including facial features, body types, age, personal details, composition, and background, among others. This section will introduce you to some of these various other elements that can further enhance your figure drawing and portraits.

YOUNG CHILDREN

Accented dark lines contrasted with soft, light values bring an interesting element to the rendering of this baby.

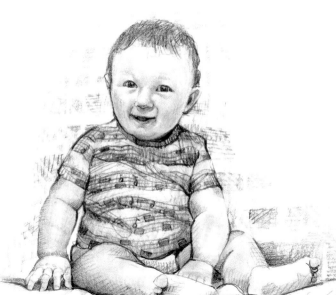

After six months or so, babies have the neck, upper body, and back muscle strength to sit upright like this. Soft contours and rounded shapes accentuate this infant's chubby arms and legs, as well as his soft skin.

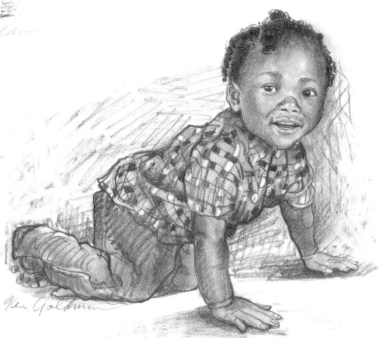

Babies generally begin crawling between seven and ten months, thinning out slightly as they burn more energy throughout their days. In these few months before learning how to walk, these almost-toddlers are constantly on the move, exploring their environment with newfound freedom.

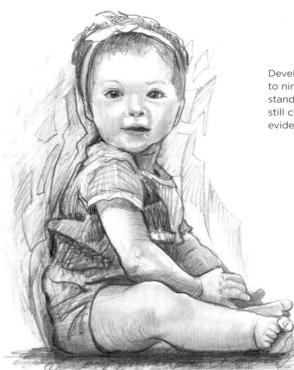

Developmental milestones for a seven-
to nine-month-old infant include sitting,
standing, and laughing. Although
still chubby, a little more definition is
evident in the body structure.

The smooth, exposed face of this heavily
bundled tot is foreshortened from the
top. The placement of the eyes on an
arc shows the roundness of his head
beneath the knit cap.

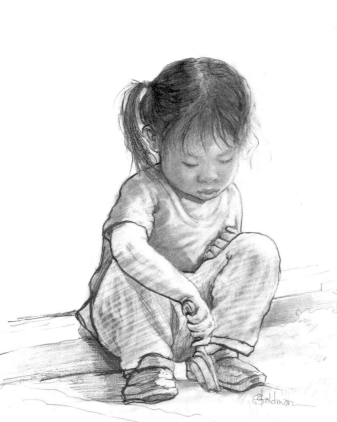

Sometimes the shape of a pose is more
important to a viewer's appreciation
than the details of the pose itself.

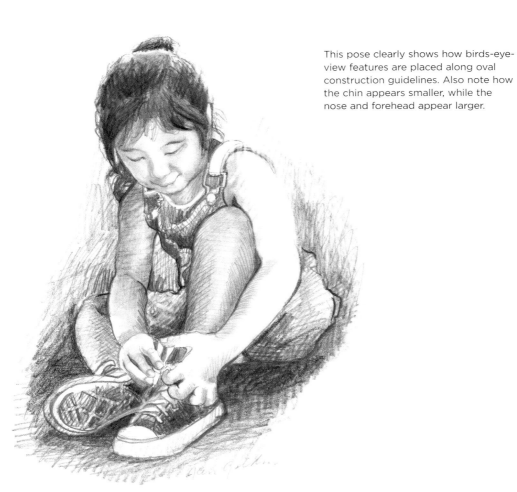

This pose clearly shows how birds-eye-view features are placed along oval construction guidelines. Also note how the chin appears smaller, while the nose and forehead appear larger.

This girl's facial expression and hand gestures are unique and captivating. To emphasize this, her head and hands remain sharp, while the rest of the figure is drawn softly. Strong outlines help ground the figure in the scene.

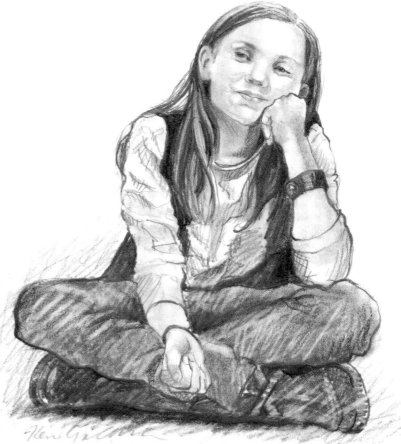

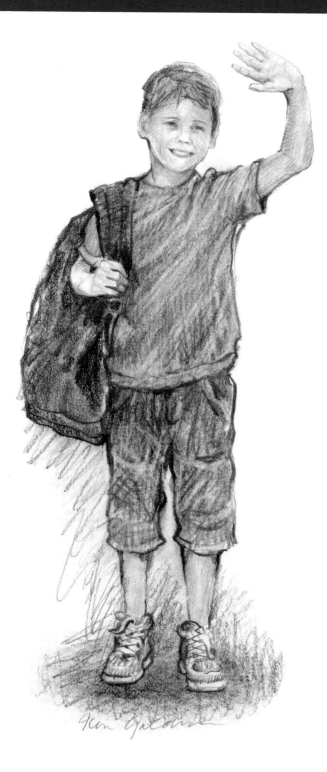

Fabric folds always drop from a tension point. Because this boy's left arm is raised, all folds drop from his raised shoulder, including those reflected in his backpack.

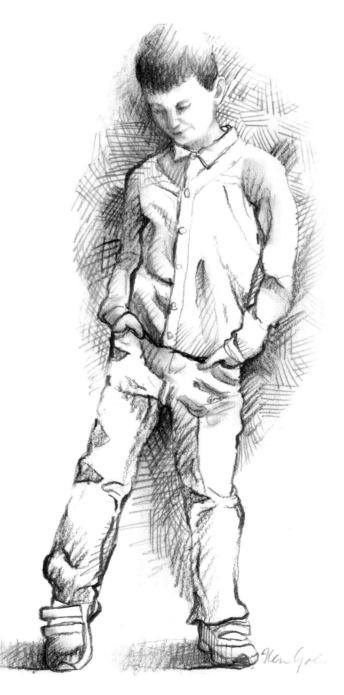

What does this figure's expression, when combined with his stance, suggest about the mood he might be in? Is it contemplative or uncertain—content or melancholy? Introducing a bit of ambiguity into your work can make for an interesting piece.

TEENS & YOUNG ADULTS

Although they have grown into adult features and proportions, teens and young adults still radiate a youthful essence that should show through in a drawing. Consider body language, playful expressions, clothing, and environment as you plan your drawing.

What makes this figure so interesting? Details such as a striped sweater, fingerless gloves, and knit cap with tassels indicate her age, while her hand gestures suggest she is feeling carefree. The strong triangular composition and the mischievous upward glance add to this drawing's interest.

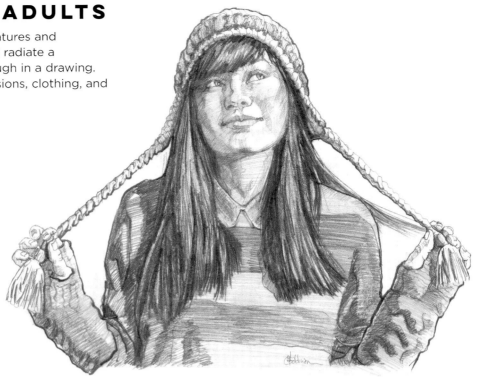

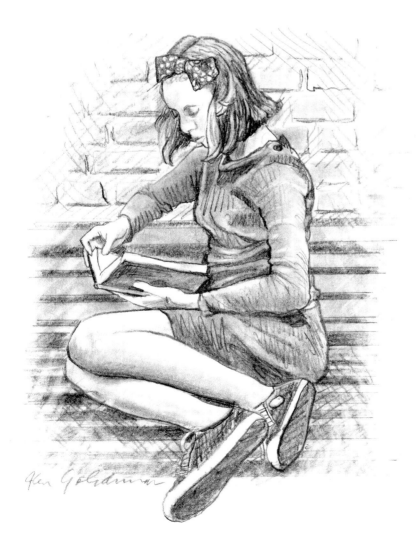

This pensive pose shows a quiet moment in a school stairwell, away from the chaos of fellow students. Her body is turned away from the viewer as she focuses all of her attention on the book. The bow in her hair, youthful shoes, and apparent unawareness of the viewer hint at the model's innocence.

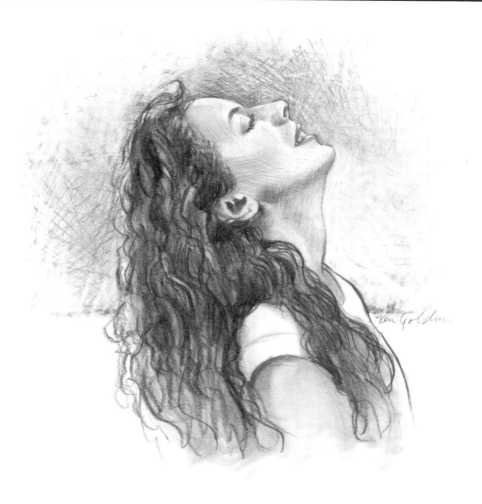

Viewed straight on at eye level, the ears normally would align with the brows and the base of the nose; however, this head, tossed back, puts the ears below the nose. A clearly defined profile and distinct facial features help communicate that this woman's mood is one of serenity.

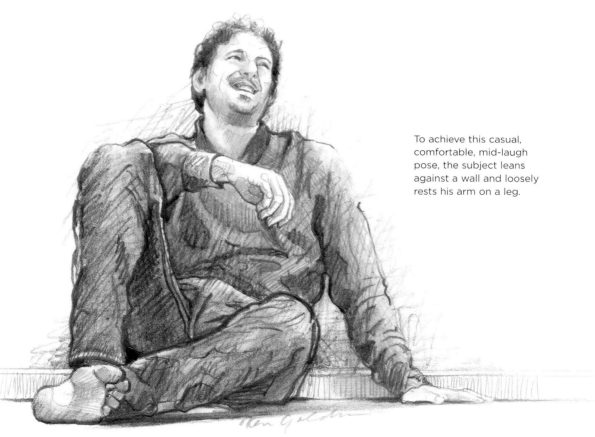

To achieve this casual, comfortable, mid-laugh pose, the subject leans against a wall and loosely rests his arm on a leg.

MATURE ADULTS

Mature subjects often carry themselves with an ease and confidence that you'll want to convey in their poses. They can also be quite fun to draw, as wrinkles, glasses, and hats add interest and character.

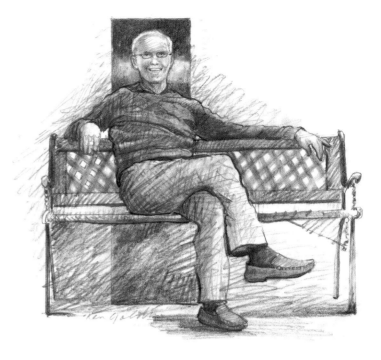

This is another variation of a relaxed pose, which has been balanced out with a strong vertical background and a subtly triangular composition. A few light hatch marks on this figure's face are enough to suggest his advanced age.

Look for the basic shapes in this seated pose—a rectangle for the torso, a diamond for the legs, and an oval for the face. By looking for these simple shapes, you can draw just about any pose, body type, and age group. A mid-toned background with dark, diagonal strokes to contrast with the light, horizontally striped shirt adds a bit of visual interest.

In this pose, the interest comes primarily from one leg edged slightly forward, as well as contrast between the light shirt and dark pants. Use a kneaded eraser to lift out highlights from the hair to suggest salt-and-pepper coloring.

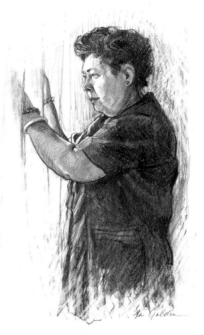

Bright light passing through a translucent curtain provides an opportunity to depict the effect of hands behind a semi-transparent curtain fold.

Adding slightly graduated diagonal strokes to the background adds interest behind these two vertical figures.

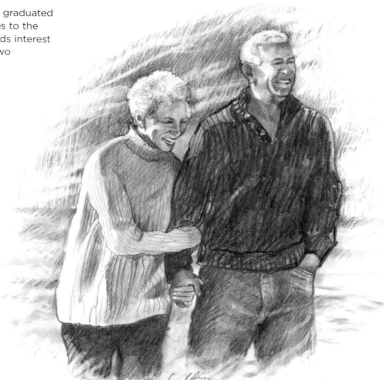

The light source in this drawing is coming from the left side of the frame and slightly behind the couple.

In this scene, a dark background provides effective contrast as it brings out the lighter shapes of this sitting couple. Dark tones applied in the background can often work to brighten a subject made of primarily light to middle values.

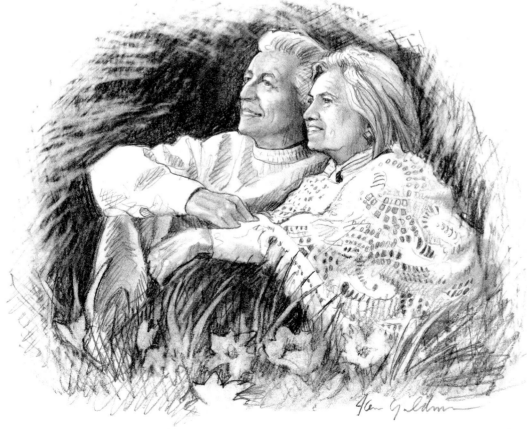

Many of these textures, including the shawl, grass, flowers, and background were created by alternating between a pencil, blending stump, kneaded eraser, and vinyl eraser.

PORTRAIT OF AN OLDER WOMAN

1

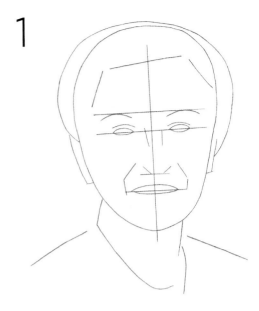

Start with basic shapes and lines to indicate placement and angles.

2

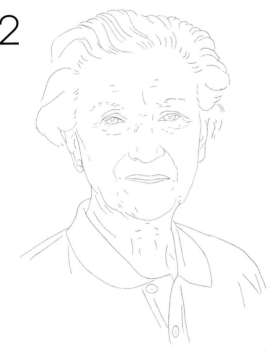

Tape a piece of heavy tracing paper over the sketch and outline the face and hair. Refine the ears and facial features, using broken lines to shape the eyebrows, the folds under the eyes, and the deep creases around the face. As you draw the neck, pay attention to the shadows created by aging. Then outline the shirt.

3

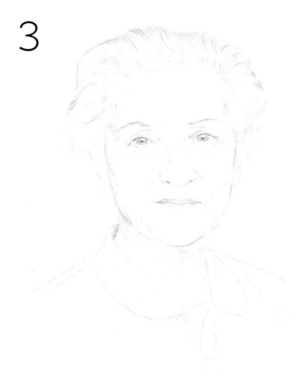

Transfer the drawing to a clean sheet of drawing paper and use an HB pencil to add long, light strokes in the hair. Lightly shade the side planes of the face and nose. Add shading to the facial features, using short strokes for the lips and eyebrows. Then shade the neck and shirt.

4

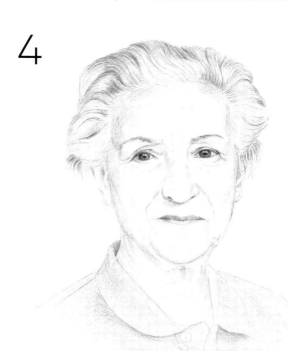

Add subtle shadows in the light hair. Then darken the eyebrows, irises and pupils, and lips. Build up another layer of shading on the forms of the face, ears, and neck. Then delicately shade around the eyes, add more tone to the side planes of the nose, and deepen the shadow below it. .

5

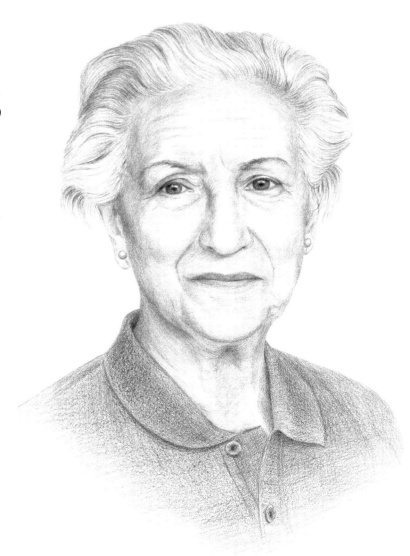

Continue to build up tone in the face and neck and very lightly model the light areas of the face, such as the cheeks and forehead. Use the side of a 2B pencil to deepen the value of the shirt.

SHOWING MOOD & EMOTION

One of the most rewarding aspects of figure drawing is the ability to move beyond shapes and outlines to evoke human emotion. As you explore this section, focus on how each element of the scene—from line quality and range of value to expressions and body language—work together to establish a cohesive mood and atmosphere.

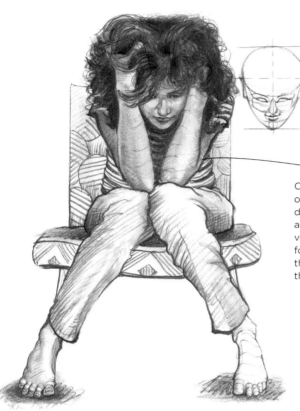

Cross-contour lines on the arms and foot demonstrate how strokes are used to create volume. They should follow the direction of the volumes for which they are used.

The graceful diagonal formed by the pregnant belly is echoed by the position of the right leg. This drawing captures a look of peaceful anticipation on the face of this mother-to-be.

In this melancholy drawing, the girl's hair obscures her face from the viewer. Her body's position, combined with her head in her hands, suggests a discouraged or downcast mood. Use egg and cylinder shapes when blocking in the head at a downward-tilted angle.

This woman's detailed eyes show great surprise that borders on shock and are the clear focus of this drawing. The loosely rendered remaining features, including the hands, body, and hair, help keep the focus where it belongs.

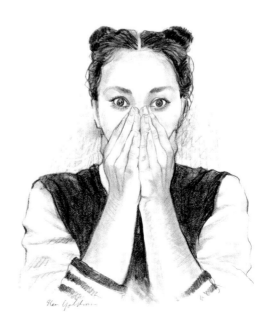

A more intense version of the pose on the opposite page, the hands completely shield the face and suggest a desire to be left alone. A feeling of despair is further communicated by the toes pointed inward, along with monotone values and jagged lines.

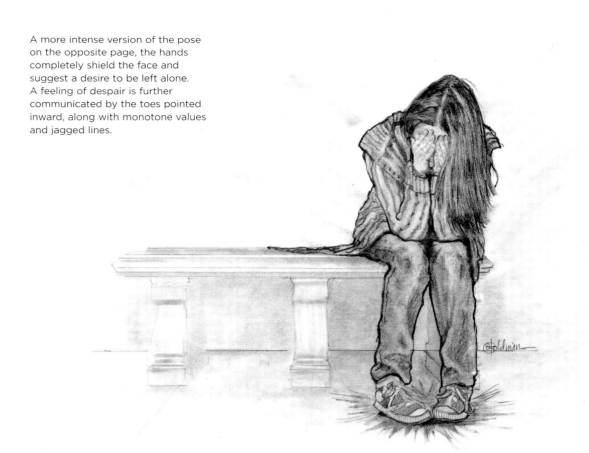

In this pose, there is interplay between light and dark with accents of line. Defining form through extreme value contrast is called "chiaroscuro." With the light source focused on the figure's face, the viewer is able to take in the look of intensity, while the rest of the body is enveloped in shadow.

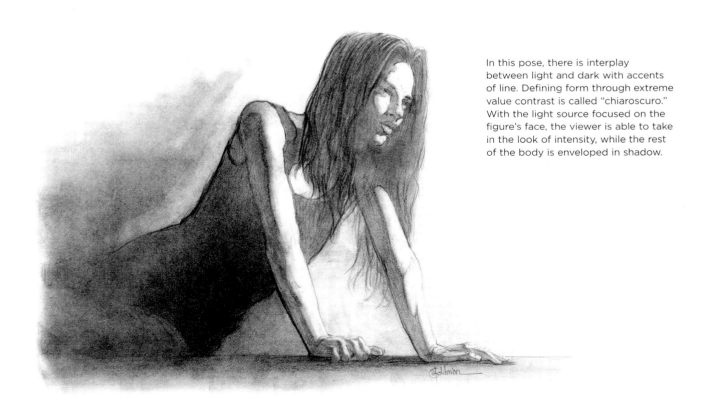

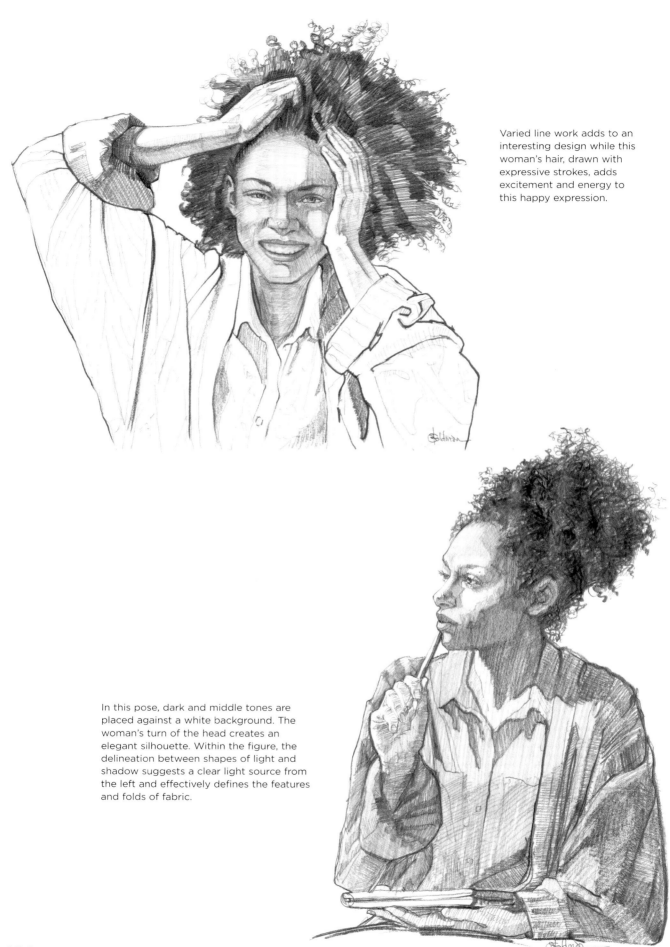

Varied line work adds to an interesting design while this woman's hair, drawn with expressive strokes, adds excitement and energy to this happy expression.

In this pose, dark and middle tones are placed against a white background. The woman's turn of the head creates an elegant silhouette. Within the figure, the delineation between shapes of light and shadow suggests a clear light source from the left and effectively defines the features and folds of fabric.

This pose becomes a stronger image by unifying the arms and head into one pattern, which contrasts with the darker patterns of the shirt, pants, and shoes.

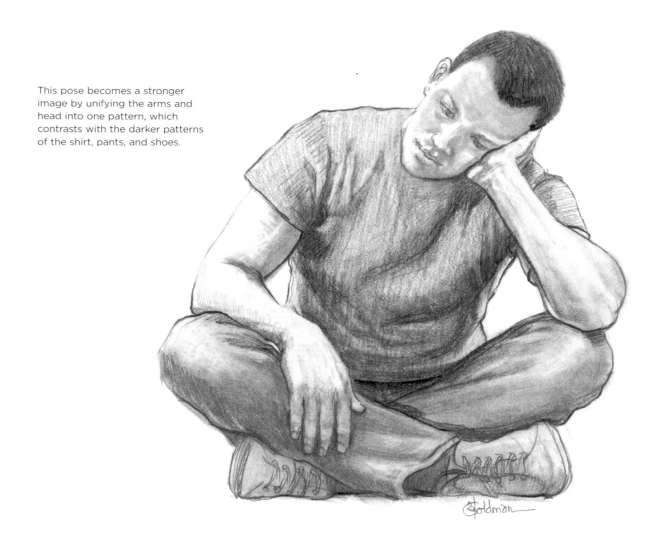

Creating Drama

A darker background can add intensity or drama to your portrait. Here the subject is in profile, so the lightest values of her face stand out against the dark values of the background. To ensure that her dark hair does not become "lost," create a gradation from dark to light, leaving the lightest areas of the background at the top and along the edge of the hair for separation.

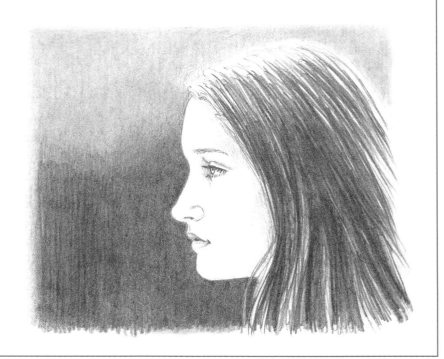

The pensive expression on this young boy's face is further accentuated by his contracted posture.

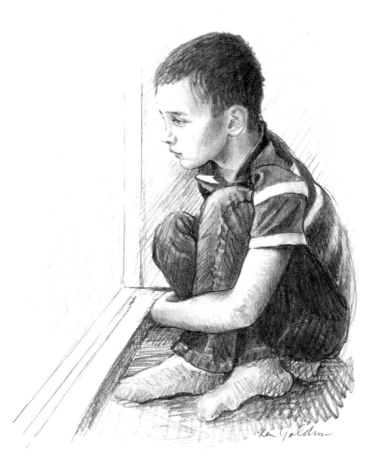

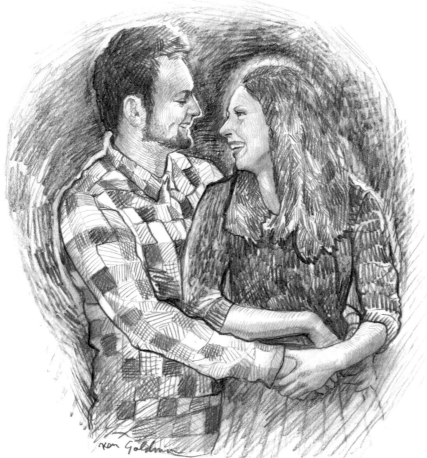

The values in this drawing are built up entirely through crosshatching over blended and unblended areas. Final hatch marks follow the established forms.

Just for Practice

Expressive poses often come down to the eyes. This lesson will help you master drawing them.

1

Begin by lightly laying in the basic shapes and outlines with an HB pencil, checking the proportions for accuracy.

2

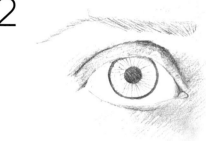

Stroke in a layer of tone, building the shadowed areas to suggest form. Use softer pencils for the darker areas.

3

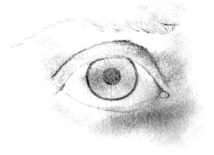

Blend the tone to create a smooth base that hints at the value pattern you see in your model or reference. Blend the skin surrounding the eye, and use stumps for the darker, linear areas, including the eyebrow, crease, iris, and pupil.

4

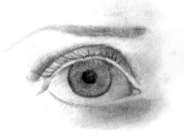

Because blending the tone lightens the overall values, reapply tone, blend, and repeat where needed.

5

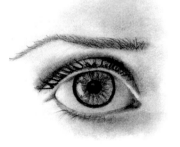

Add fine lines and create highlights. Fill in the eyebrow with short strokes in the direction of hair growth. Use an 8B for the darkest accents, such as the pupil and eyelashes, blending subtly with a stump. Use a kneaded eraser to gently dab away tone to model the forms and soften any harsh edges. Then use a stick eraser to pull out the highlights in the iris.

PORTRAIT OF A YOUNG GIRL

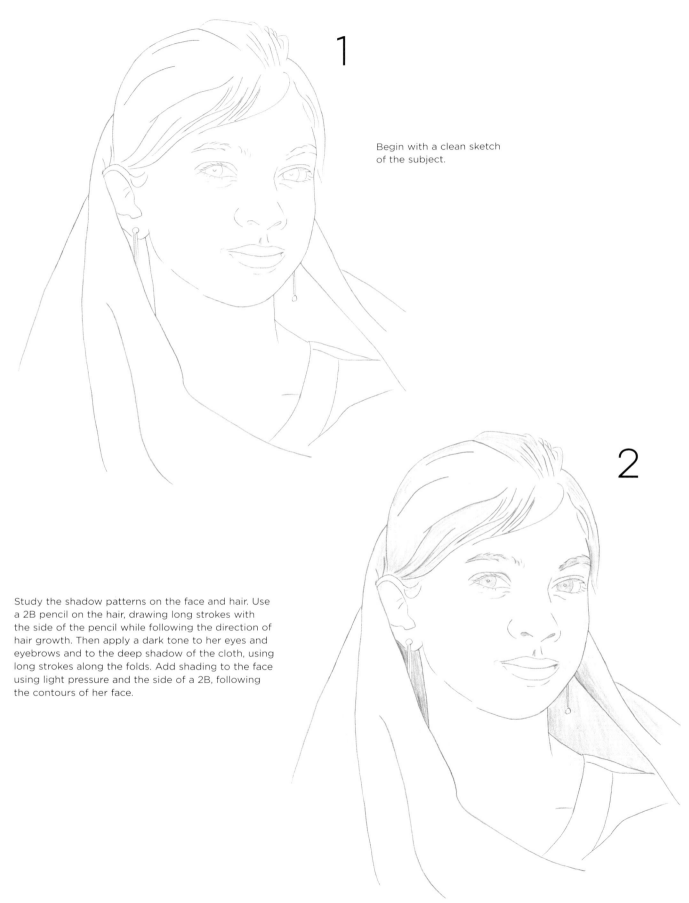

1

Begin with a clean sketch of the subject.

2

Study the shadow patterns on the face and hair. Use a 2B pencil on the hair, drawing long strokes with the side of the pencil while following the direction of hair growth. Then apply a dark tone to her eyes and eyebrows and to the deep shadow of the cloth, using long strokes along the folds. Add shading to the face using light pressure and the side of a 2B, following the contours of her face.

3

Use the side of a 4B to darken the shadows of the hair, and then switch to the point of the 4B to draw long, curved lines that follow the direction of the strands. Use heavy pressure to deepen the dark tone of the cloth behind her neck, and then use a 2B to deepen the shading of her eyes, using both circular and radial strokes but leaving the highlights white.

4

Begin adding deeper tones of shading with heavier pressure. Then use an HB to begin adding subtle shading to the light sides of the forms. Use the HB to refine the shading in the eyes, being mindful of the spherical shape of the eyeball as you develop the "whites." Use the point of a kneaded eraser to clean up the highlights of the eyes.

5

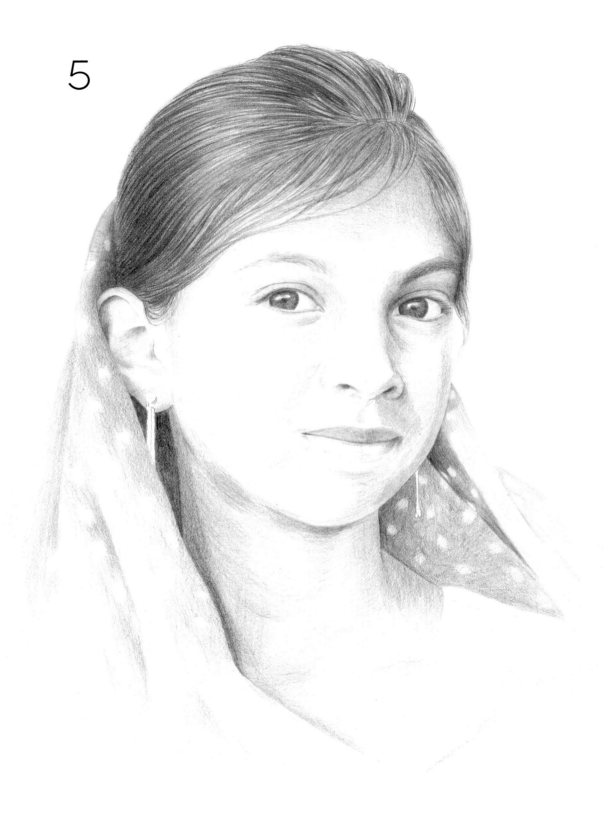

Return to the 4B pencil to build up the texture of the hair. Use both the side and point of the pencil as you stroke, always following the direction of the hair. Also, develop the dark shadows of the cloth with the 4B, using the point of an HB to refine the edges of these shadows. Continuing to work with the HB, build up tone on the light side of the face, always following the contours of the features. Then work in the shadow side, building up with the HB to refine the shading. Use the pencil's point to carefully refine the shapes of the features. Add some detail to the earrings with the HB, and draw individual strands of hair around the forehead.

6

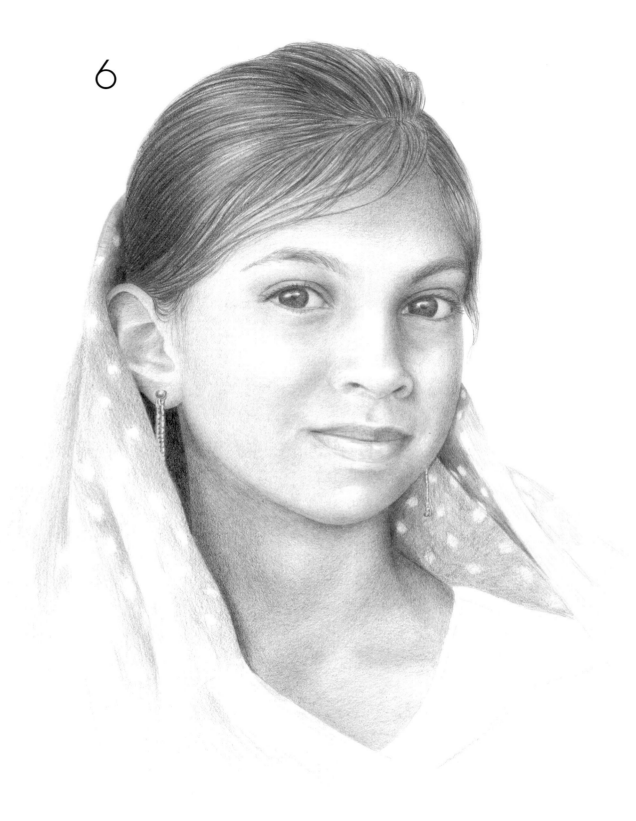

In this "polishing" stage, carefully rework the shading of the face. Lightly use the point of the HB to fill in uneven areas, and use the kneaded eraser to lightly lift out tone that is too dark. Finish the portrait by adding more shading to the cloth with light crosshatching. When finished, clean up any remaining smudges with a kneaded eraser.

Chapter 5

COMPO

SITIONS

COMPOSING WITH PURPOSE

Composition refers to the arrangement of elements within a drawing and lays the groundwork for a visually pleasing work of art. A good composition creates a sense of balance and movement; it draws in the viewer's eye and points it to the most important aspects of the drawing. In this chapter, explore composition as it relates to figure drawing and consider its effects on the mood and message of each piece.

When drawing figures in graphite pencil in front of a landscape, keep the background light and simple so as not to detract from the subjects in the scene.

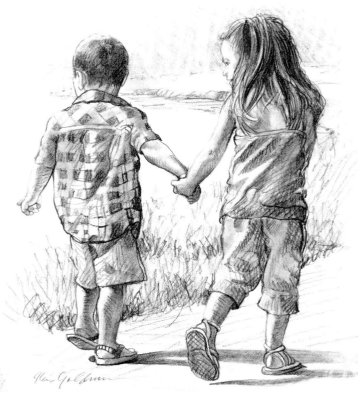

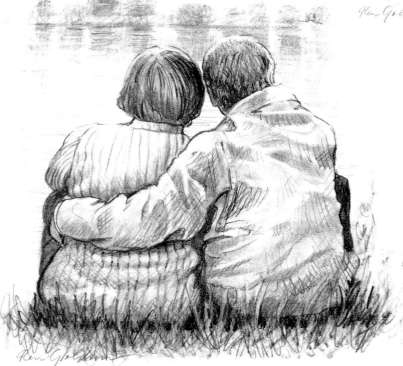

This mood of tender serenity is further enhanced by the use of light, horizontal background strokes in contrast to the vertical, more active foreground strokes.

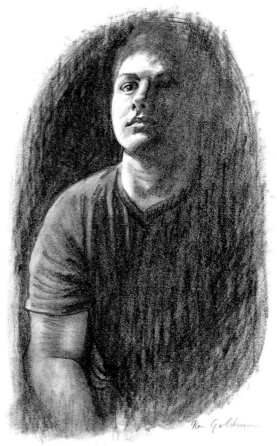

This dynamic composition shows a form half enveloped in dark shadow with the light source coming from slightly above. The mood is serious and contemplative, making for a dramatic visual piece. Forms are most recognizable where hard edges meet. In portraiture, this is called a focal point. All other less important areas have soft or lost edges.

A low viewpoint with extreme foreshortening, as in this man's hands, adds interest and drama to a composition. In this example, the man's prayer beads dominate the overall design and suggest the significance of faith in his life. The focal point of this drawing—a mature hand holding beads—is rendered with great detail while all other areas are deliberately left vague.

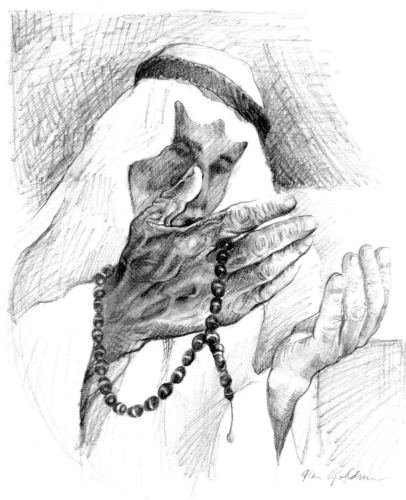

To highlight the closeness of this mother and child, the figures are massed together. Notice how the diagonal line of the baby's body mirrors the line of the mother's arm, giving the composition flow.

"Backlighting," also called "rim lighting," occurs when the light source is positioned behind the subject. You can use this to create a silhouette-driven composition with soft shapes and an intimate, atmospheric quality.

Simple line work and a limited range of values give this scene the clarity and contrast needed to visually distinguish the two subjects.

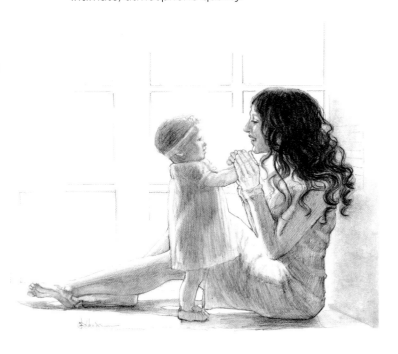

When figures are lit from behind, all details are subordinated to a range of middle values. Leave the background bright and simple to keep the focus on your subjects in the foreground.

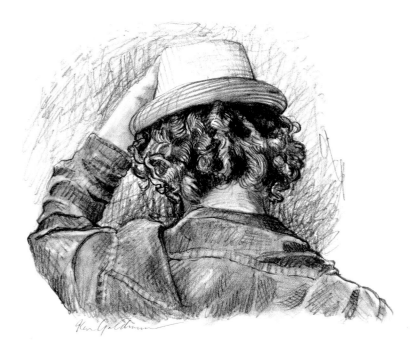

Consider unconventional viewpoints for your portraits, which can capture a model's sense of style or body language without even featuring the face.

Sketching cylinders gives a starting point to further developing the curls of hair. Use arrows to represent the light source so you know where to add shading.

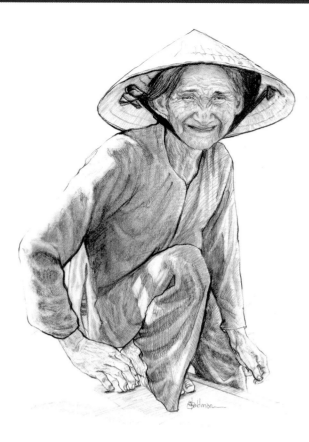

This woman is rendered with expressive lines that vary in thickness. The broken or "lost" lines that define the edge of the right arm indicate bright light coming from the upper left, inviting the sun—although not actually drawn—into the composition.

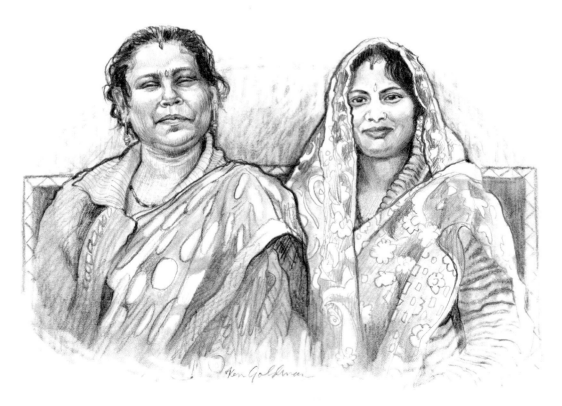

Two side-by-side figures centered on a bench make for a balanced composition with a sense of symmetry. In this drawing, overlapping the figures slightly creates a more unified mass, preventing any awkward negative space between the figures. Keep this in mind as you position your models. When incorporating patterned fabrics into a portrait, it's best to avoid designs with high contrast and excessive detail. Keep the darkest tones and most intricate work on the heads, which serve as the clear focal points of the piece.

The weight and focal point lie near the bottom of this drawing, creating a stable, centered composition echoing the meditative seriousness of the figure. The wristwatch at right brings a bit of variation to the symmetrical scene. In addition to using 2B and 4B pencils for this rendering, a kneaded eraser and a blending stump help lift out highlights. The figure's face is secondary to the focus—the folded hands.

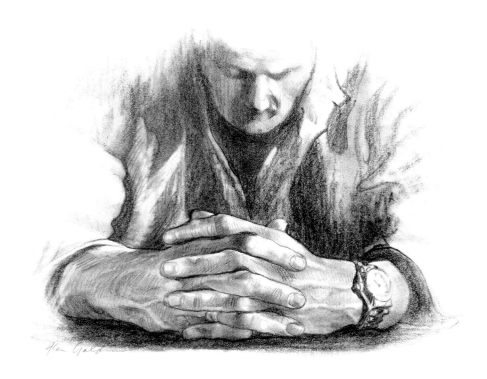

This portrait of boys uses a traditional triangular (or pyramidal) composition, which creates stability while incorporating diagonal lines for interest. This compact arrangement also exudes a sense of emotional closeness between the boys.

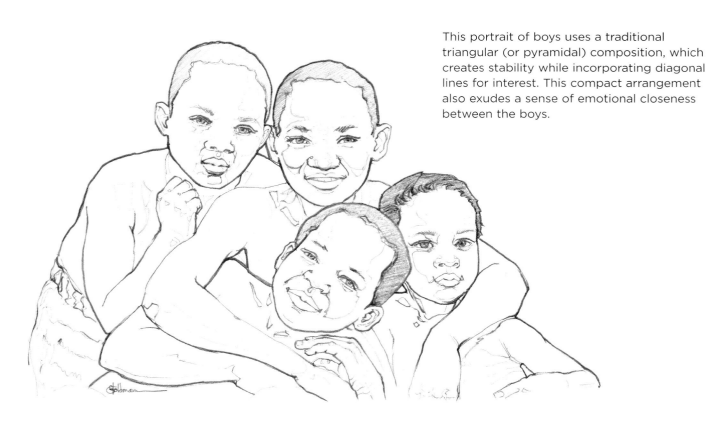

Odd-numbered groups generally create a more interesting composition than even-numbered groups.

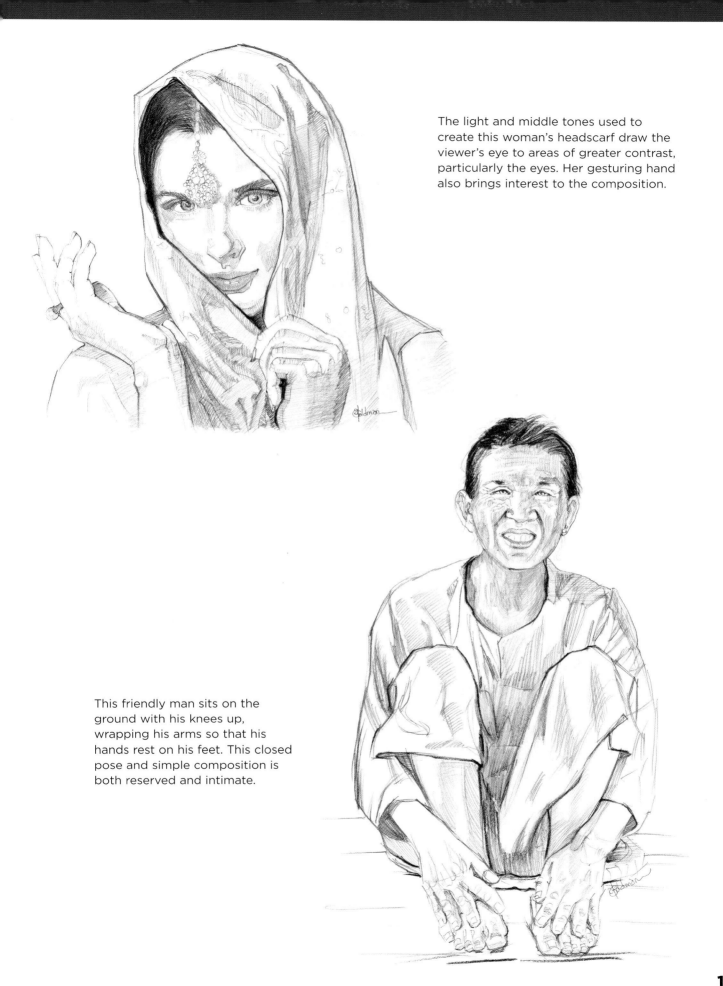

The light and middle tones used to create this woman's headscarf draw the viewer's eye to areas of greater contrast, particularly the eyes. Her gesturing hand also brings interest to the composition.

This friendly man sits on the ground with his knees up, wrapping his arms so that his hands rest on his feet. This closed pose and simple composition is both reserved and intimate.

DANCER

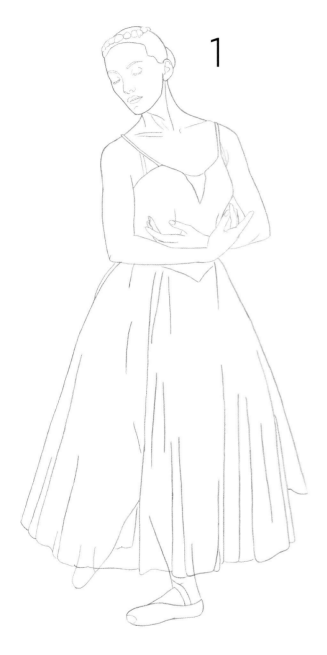

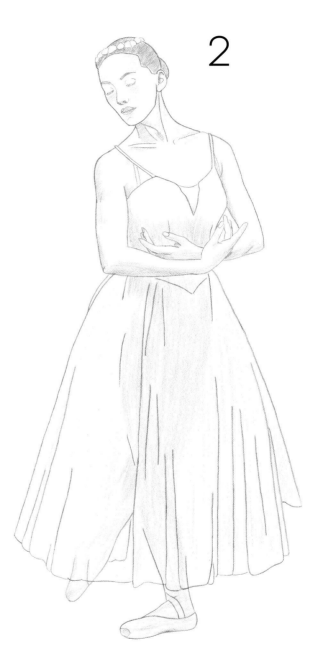

First sketch the outlines of the figure. A simple, sleek, and airy composition perfectly suites this ballerina. The overall shape of her pose is an elongated triangle, which creates a sense of stability and balance. The long lines of her dress folds lengthen the appearance of her body to add flow and elegance.

Start establishing a base tone for the shadows and dark values by using the side of a 2B pencil to lay down a layer of tone in the hair. Then add dark tone to the eyebrows, lips, and nostrils. Using lighter pressure, add shading to the delicate shadow areas of the face, neck, and body. As always, use strokes that follow the form. Add some light tone to indicate the form of her legs, which can be partially seen through the transparent material. Then add some light tone to the dress using long, vertical strokes.

3

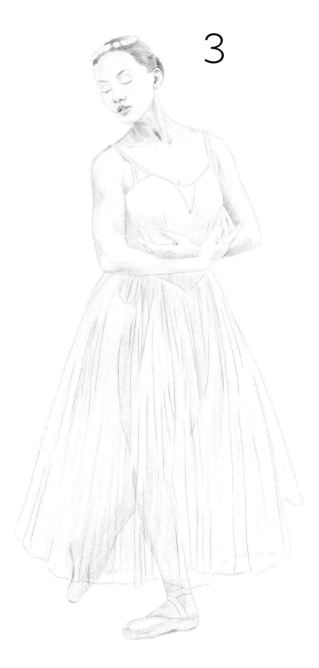

4

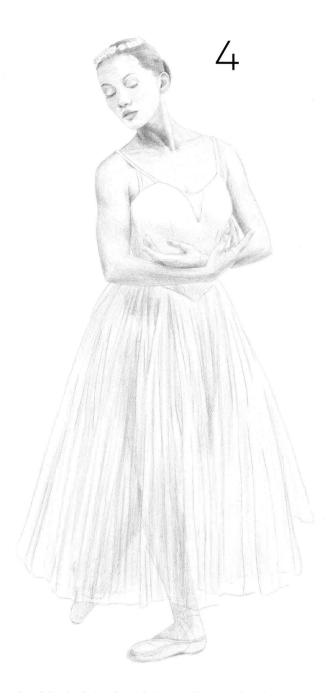

Return to the hair, stroking with the dull point of a 4B pencil in the direction of hair growth. Add more tone to the shadow side of the face using a 2B, noting that the light falls most directly on the side. Work around the body, adding more tone to areas where the forms turn away from the main light source. Add more shading to the upper part of the dress, again using strokes that follow the form of the body. Loosely add more long lines to indicate the folds of the dress.

Carefully shade her facial features with curved strokes that follow her form. Do the same around the neck area, shading the forms that indicate the underlying muscles of the neck. Continue to work around her arms and chest, and begin to shade her hands. As you work on her hands, remain aware of the small forms and shade delicately.

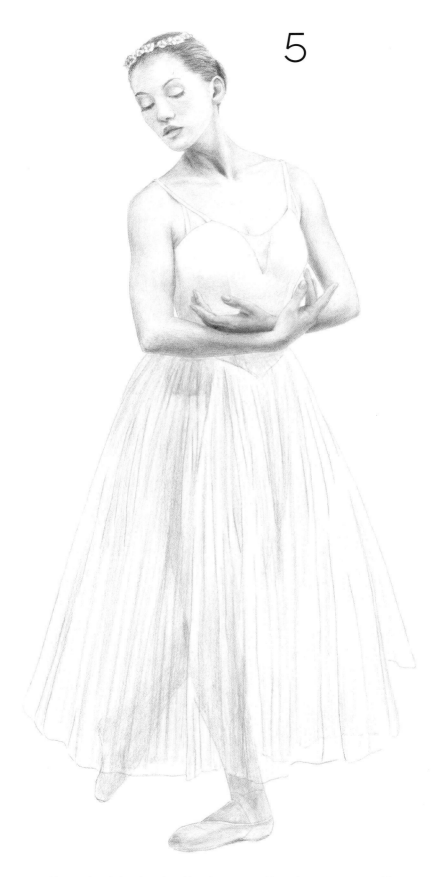

5

Return to working on her hair using the side of a 4B to achieve deeper tones, working softly around the hairline. Then use a sharp 2B to add a few lines for additional texture. Use the HB to delicately shade the flowers in her hair.

6

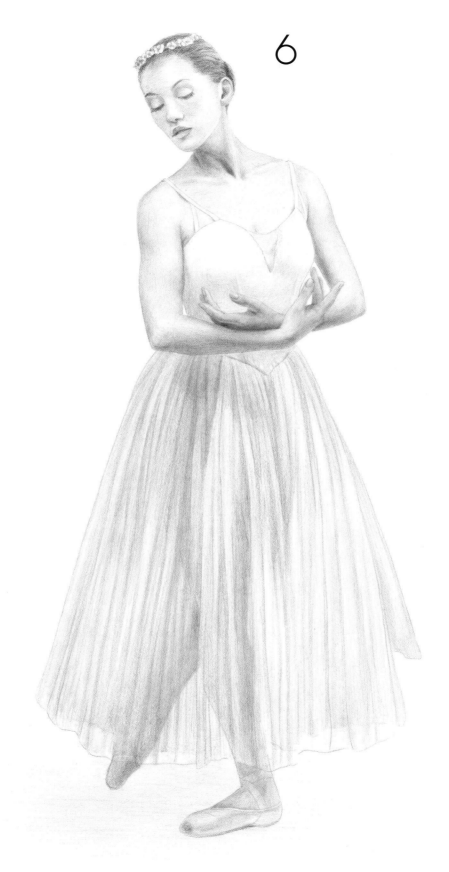

Focus on the folds of the dress and deepen the shading with long, vertical strokes. You don't have to draw each fold exactly; instead, work loosely and quickly to suggest texture.

SECRETS TO CREATIVITY

The fastest way to improve your drawing skills and stretch your "creativity muscles" is to develop two essential habits.

Sketch Every Day Sketching not only develops your hand-eye coordination, but it's also a wonderful way to connect with the visual world around you. Carry your sketchbook around with you everywhere, and draw as many different types of subjects in as many different poses as possible. You will soon find yourself getting inspired and will have many ideas for drawings from your sketchbooks.

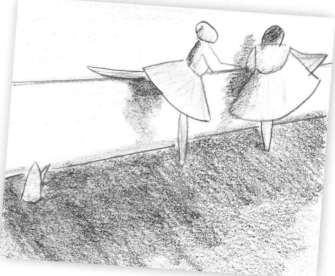

Sketch from Old Masters' Work The Old Masters were thoroughly trained in their craft, and their drawings contain knowledge that can be absorbed when you copy them. It is great to do quick sketches of their work to get a sense of their compositions. And don't be afraid to use one of their compositional ideas—great artists have copied compositions from other great artists for centuries!

Speed Sketching

So often, we feel that we don't have the time to take out our sketchbooks to draw. But even if you only have five minutes, you can benefit from "speed sketching." The idea is to quickly put down the big shapes, lines, and angles of your subject, which are the armature of any drawing. By frequently practicing speed sketching, you will find yourself learning to ignore detail (because there is no time for detail in five minutes!) and looking at the main large shapes and angles.

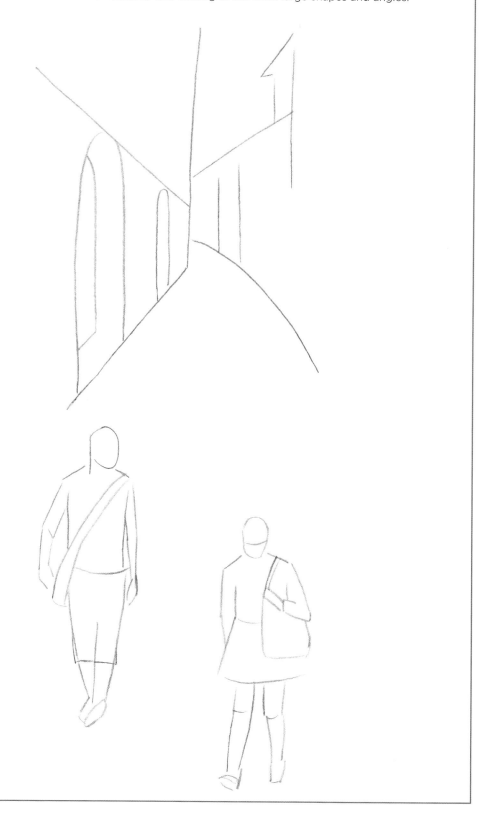

ABOUT THE ARTISTS

Ken Goldman is an internationally known artist, author, teacher, and art juror. A recipient of numerous awards, Goldman has exhibited widely in various group shows and solo exhibitions in the Netherlands, France, Mexico, China, Italy, Greece, New York, Boston, and Washington, D.C. Goldman's work is included in the permanent collections of the San Diego Museum of Art, North Carolina's Hickory Museum of Art, the San Diego Natural History Museum, the San Diego Watercolor Society, and the Zuo Wen Museum in Qingdao, China. Ken is the author of 15 Walter Foster books on pastels, acrylics, charcoal, and artistic anatomy and has been featured in many magazines, including *The Art of Watercolour*, *Southwest Art*, *International Artist*, *Watercolor Magic*, *Splash 12*, *Splash 13*, and *The Artist's Magazine*. Ken teaches figure painting, artistic anatomy, and plein air landscape at the Athenaeum School of the Arts in La Jolla and in workshops across the country and has served as president of the National Watercolor Society. Ken's education includes the National Academy of Design, Art Students League, and the New York Studio School. For more information, visit goldmanfineart.com, californiawatercolor.com, and facebook.com/1goldmanfineart.

Stephanie Goldman is known for her richly colored figures, insightful portraits, boldly painted miniatures, and dynamic charcoal, pencil, and ink drawings. She imbues all of her work with focused creativity and experimentation that intrigue collectors and critics alike. Some of her exhibitions include 15 unique portraits of children entitled "I Am A Child at The Riverside Art Museum," "Bearing Exquisite Witness" at the Joan B. Kroc Institute for Peace and Justice, a special portrait unveiling of director Erika Torrey commissioned by the Board of Trustees for the Athenaeum in La Jolla, and many group exhibitions, including the San Diego Museum of Art, Gotthelf Gallery-La Jolla, San Diego Art Institute, San Diego Natural History Museum, Hyde Art Gallery-Grossmont College, Boehm Gallery-Palomar College, and the Earl & Birdie Taylor Library in San Diego. A selection of her work has been reproduced by Frontlines Publishing, Ramprod, and East Meets West Co. Stephanie teaches figure painting and portraiture at the Athenaeum School of the Arts in La Jolla and has worked with artist Ken Goldman for more than two decades collaborating on large and small public and private art projects. For more information, visit goldmanfineart.com, californiawatercolor.com, and facebook.com/1goldmanfineart.

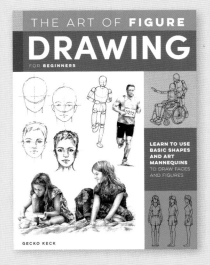